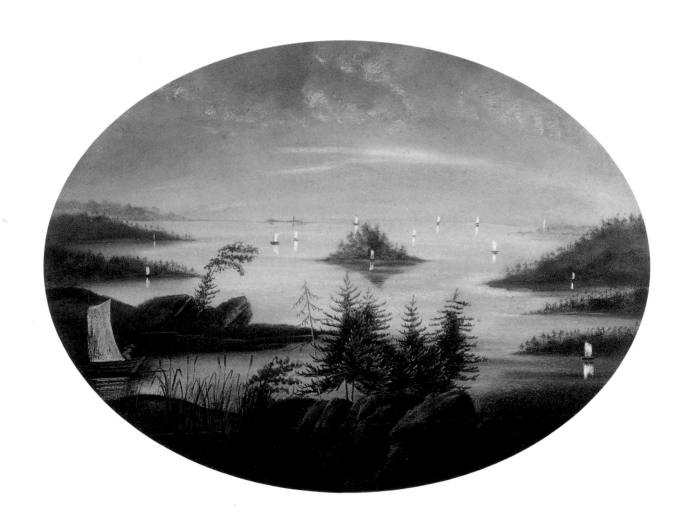

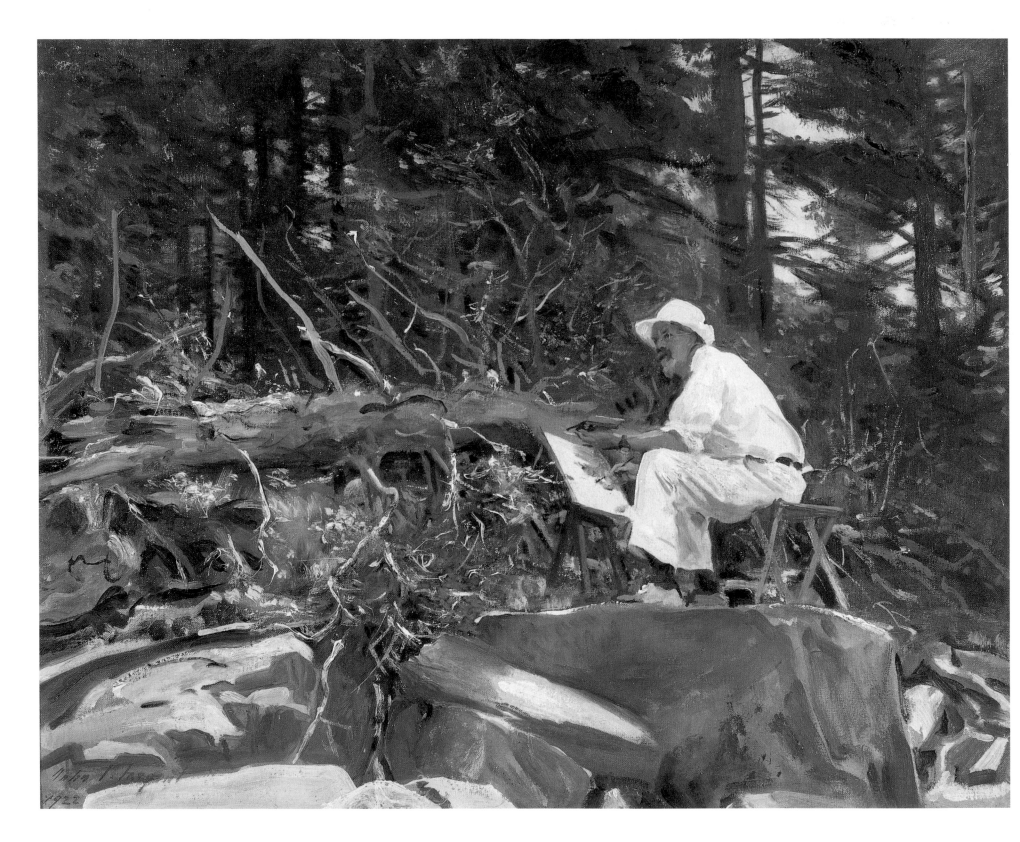

A CHAMELEON BOOK

Art of the Maine Islands

By Carl Little
Picture Editor, Arnold Skolnick

DOWN EAST BOOKS, CAMDEN, MAINE, 1997

A Chameleon Book

Copyright © 1997 by Chameleon Books, Inc.
Text © 1997 Carl Little

Published by
Down East Books
P. O. Box 679
Camden ME 04845

Produced by
Chameleon Books, Inc.
31 Smith Road
Chesterfield MA 01012

Designer/Picture Editor: Arnold Skolnick
Editorial Assistant: Laura J. MacKay
Copy Editor: Jamie Nan Thaman
Design Assistant: K. C. Scott

Printed by
O. G. Printing Productions, Ltd., Hong Kong

"Islanders," from *Relations: New and Selected Poems,* by Philip Booth.
Copyright © 1986 by Philip Booth. Used by permission of Viking
Penguin, a division of Penguin Books USA, Inc.

"The Coast of Maine," from *Maine Poems.* Copyright © 1988 by Richard
Eberhart. Used by permission of Oxford University Press, Inc.

Library of Congress Cataloging-in-Publication Date

Little, Carl.
 Art of the Maine Islands / by Carl Little : picture editor, Arnold
Skolnick.
 p. cm.
 "A Chameleon book."
 Includes bibliographical references and index.
 ISBN 0-89272-426-9 (hardcover)
 1. Islands—Maine—In art—Catalogs. 2. Landscape painting,
American—Catalogs. 3. Landscape painting—20th century—United
States—Catalogs. I. Skonick, Arnold. II. Title.
ND1351.6.L58 1997
758'.1741'0973'074—de 21
 97-27605
 CIP

(half-title)

HARRIET BEECHER STOWE
CASCO BAY, C. 1851
GOUACHE, 11 x 14 3/4 IN.
COURTESY HARRIET BEECHER STOWE CENTER,
HARTFORD, CONNECTICUT

(frontispiece)

JOHN SINGER SARGENT
PORTRAIT OF THE ARTIST SKETCHING, 1922
OIL ON CANVAS, 22 x 28 IN.
COURTESY MUSEUM OF ART, RHODE ISLAND SCHOOL OF DESIGN
GIFT OF MRS. HOUGHTON P. METCALF

Acknowledgments

Many artists are to be thanked for providing material for this book — including those individuals who, due to space restrictions, are regrettably not represented. Special thanks to Dahlov Ipcar, Siri Beckman, Thomas Paquette, Peggy Zorach, Nicholas Snow, David Little, Gertrude McCue, Thomas Crotty, Eleanor Levin, Barbara Iselin, Brita Holmquist, Dan Fernald, Sara Weeks Peabody, Michael Lewis, Joan McD. Miller, Jill Hoy, Jon Imber, Janice Kasper, James Linehan, Samuel Shaw, Joellyn Duesberry, Janice Anthony, Nina Jerome, William Carpenter, Yvonne Jacquette, Francis Hamabe and Jamie Wyeth, who has been so generous.

We are also grateful to the Rhode Island School of Design, Brown University, the Brooklyn Museum of Art, Phillips Academy, the Columbus Museum of Art, the Metropolitan Museum of Art, the Farnsworth Art Museum, the Portland Museum of Art, the Harriet Beecher Stowe Foundation, the Snowe-Day Foundation, the Smith College Museum of Art and the Martin Memorial Library for producing transparencies. The following galleries contributed key pictures: O'Farrell, Caldbeck, Bayview, Frost Gully and Gleason in Maine; Mary Ryan, Tibor de Nagy, David Findlay, Jr., Kraushaar, Marlborough, Jordan-Volpe, Spanierman and DC Moore in New York; Locks in Philadelphia; and Chase and Vose in Boston.

Many thanks to the private collectors — many of whom remain anonymous — who permitted us to reproduce art from their collections.

Thanks are due as well to a number of excellent fine-art photographers, including Warren Hill, Jay York and Peter Ralston. They are artists in their own right.

Many individuals deserve tribute for their dedication to the islands of Maine, including Charles and Carole McClane, Ted Spurling, Hugh Dwelley, the late Gladys O'Neil and the host of others devoted to recording island histories. Philip Conkling and his excellent staff at the Island Institute have gone a long way toward raising our consciousness regarding the preciousness of the islands and the necessity of stewardship and an island ethic.

We also salute the late Elizabeth Noyce (1931–1996), who was responsible for adding a number of the paintings that appear in this book to Maine museum collections. Thanks to her, Mainers are now able to enjoy some of the masterpieces created in their state.

This book is dedicated to my family — Peggy, Emily and James — and to our collective kin, especially my uncle, William Kienbusch (1914–1980), who brought us Littles to Maine, to Great Cranberry Island, where we discovered a northern paradise.

The author and editor make a special dedication to Alan Gussow (1931–1997), Maine island artist, whose book *A Sense of Place* (1970) set the standard for environmentally-based artbooks. What Gussow wrote in the foreword to that book holds true for the present one as well:

This is a book about the qualities in certain natural places which certain men and women have responded to with love. Because these men and women were artists, they have left a record of their encounters with the land for others to see, read, and understand. This is really all that sets them apart — that talented connection between eye, mind, and hand. For all of us have our loved places; all of us have laid claim to parts of the earth; and all of us, whether we know it or not, are in some measure the products of our sense of place.

C. L.

WILLIAM KIENBUSCH, *AUTUMN ISLAND, STILLSCAPE #2,* 1974, CASEIN ON PAPER, COLLECTION OF ELLEN L. SUDOW AND JOSEPH R. HIGDON

Introduction

For some reason that I cannot explain there is an intensity to life on an island; beauty is exaggerated, is felt more deeply.

—Caskie Stinnett, *One Man's Island*, 1984

THE MAINE ARCHIPELAGO has been attracting artists since the early years of the nineteenth century. A host of the country's most eminent landscape painters made it to Mount Desert Island by the 1840s, drawn by reports of scenery that rivaled, if not surpassed, that of the much-celebrated Hudson River Valley. It's a known fact that Frederic Church and John Kensett were the first people to sign the register at the Agamont Hotel, the only such establishment in Bar Harbor in 1858.

The studies and full-fledged canvases that these painters made of the area not only gained the praise of the critics but also drew the attention of city folk hungry for nature at its most sublime. In their own way, these artists opened up a new territory on the map of the American sightseer. They also laid the foundation for future artists, who sought and found inspiration along the ironbound littoral.

Mount Desert became one of the most popular islands for artists, and it has remained so to this day. Yet men and women bearing sketch pads and easels also started turning up in force on Monhegan, Deer Isle, the Cranberries, Islesboro, North Haven, Vinalhaven and the Isles of Shoals. Something Rockwell Kent wrote in his autobiography, *It's Me O Lord* (1955), might have served as their rallying cry: "[Monhegan Island] was enough for me, enough for all my fellow artists, for all of us who sought 'material' for art. It was enough to start me off to such feverish activity in painting as I had never known."

The island art of Church, Thomas Cole, Fitz Hugh Lane and other nineteenth-century masters has been well represented in recent books, including John Wilmerding's *The Artist's Mount Desert* and such compilations as this writer's *Paintings of Maine* and Will and Jane Curtis' and Frank Lieberman's *Monhegan: The Artists' Island*. For this reason, *Art of the Maine Islands* includes only a handful of early views.

At the same time, the author and editor were struck by the impressive and large body of island-inspired work that is currently being produced. As a result of queries sent to museums, galleries and individual artists, and through word of mouth, there arrived in the mail a veritable treasure trove of paintings and prints. It seemed as if every island in Maine had captured the heart of an artist, making the task of selection all the more daunting.

The islands represented in this book range in size from Mount Desert, which, due to its great girth, is sometimes denied island status, to Outer Basket Ledge, which is not much more than a series of rocks in Casco Bay. "The ledge is very small," painter Dahlov Ipcar wrote about the latter, "but I should think it rates as an island."

Many an island in this book is viewed from a distance, for how else can one grasp islandness? Janice Kasper's delightful *Cows or Condos* and Paul Rickert's gorgeous *The Islands* encompass the kind of prospect well known to those who travel along the coast of Maine, where flotillas of spruce-dark isles accent the horizon. As photographer Eliot Porter described it in *Summer Island* (1966):

> From a few places near Camden,...the highway rose above the foreground of trees and afforded a view of Penobscot Bay. At these points, the blue bay lay stretching away to distant land and to a hazy merger of water, sky, and fog. In the middle-distance darker blue, lenticular islands floated on the streaked, ground-glass surface like ships of a great fleet at anchor.

Some islands are shrouded in the kind of fog only a Mainer can truly appreciate, while others stand out in brilliant sunlight, with Sarah Orne Jewett's "pointed firs" etched against the blue sky. At times, islands appear mirage-like in the watery expanse. Nicholas Snow's image of Hay Island, for instance, has that atmospheric quality. "Islands have distinct personalities and infinite changes of mood," he writes. "My paintings must make room for the dark as well as the sunlit complexions of islands."

In Yasuo Kuniyoshi's surreal painting *The Swimmer*, the lighthouse island appears to be separate from the watery medium that surrounds it. Likewise, Maine-born artist Sam Cady's remarkable shaped canvas *Island from Above* has an almost prop-like presence. The wild islet in Maurice Freedman's painting *Nor'easter* appears to have fallen under the influence of a classic Maine coast storm.

Needless to say, there are many and diverse islands in this book. Along with those already mentioned, you will visit Matinicus, Pumpkin, Great Spruce Head, the Porcupines, Great Wass, Crotch, Bar and Fox. Of course, you can make the crossing to a Maine island by bridge, by a ledge at low tide, via kayak, sloop, mailboat, ferry or airplane—you can even swim. But you can also make your approach through the eyes of an artist. We invite you to make that trip in *Art of the Maine Islands*.

1

*The first place I set my foote upon in New England was the Isles of
Shoulds, being Ilands in the sea, about two Leagues from the Mayne.
Upon these Ilands, I neither could see one good timber tree, nor so much
good ground as to make a garden.*

—Christopher Levett, 1624

CERTAIN MAINE ISLANDS have served as a major source of material for an individual artist. One cannot, for example, write about the Isles of Shoals, at the extreme southwest end of the Maine archipelago, without mentioning the great American Impressionist painter Childe Hassam (1859-1935).

Thanks, in part, to the good graces of Boston socialite and poet Celia Thaxter, who invited painters, writers, musicians and other artistic folk to her summer salon on Appledore Island, Hassam frequented these stark yet lovely isles in the 1890s; he once said that he had spent some of his "pleasantest summers" at the Isles of Shoals. Hassam continued to visit after Thaxter's death in 1894.

How the Englishman Levett, cited above, would have wondered had he been able to return several hundred years later to view the magnificent gardens created by Thaxter around her house on Appledore. Hassam painted the poet and her floral creations, but he also produced marvelous oils, watercolors and pastels of the coastline, many-hued tide pools and the seaside expanses of red and white poppies. As art historian Ulrich Hiesinger has noted, "These flowering Appledore landscapes are among Hassam's finest Impressionist performances in pure color and form."

Moving farther down the Maine coast—everything is "down east" as one follows the shoreline toward Canada—one encounters Casco Bay and those "islands that were the Hesperides/Of all my boyish dreams," as Longfellow put it in his famous poem "My Lost Youth." By some accounts, the bay contains more islands than any other body of water in the United States—222 according to Herbert G. Jones, author of *The Isles of Casco Bay* (1946).

The novelist Harriet Beecher Stowe came to Casco Bay in the mid-1800s, discovering the intense beauty of the northern New England landscape and meeting its rugged inhabitants. Her novel *The Pearl of Orr's Island* (1861) was inspired by these visits. She captured the essence of the islands in this passage:

The sea lay like an unbroken mirror all around the pine-girt, lonely shores of Orr's Island. Tall, kingly spruces wore their regal crowns of cones high in air, sparkling with diamonds of clear exuded gum; vast old hemlocks of primeval growth stood darkling in their forest shadows, their branches hung with long hoary moss; while feathery larches, turned to brilliant gold by autumn frosts, lighted up the darker shadows of the evergreen.

In addition to being a writer, Stowe tried her hand at painting. *Casco Bay* depicts Diamond Cove, a popular spot for boating and picnic parties from Portland in the nineteenth century. Far more than the work of an amateur, this fine gouache compares well with a Casco Bay scene by Charles Codman, a more seasoned landscape artist who painted up and down the Maine coast in the early 1800s.

Leaping to the present century, the painter Stephen Etnier followed similar coastline peregrinations, stopping along the way to record a variety of island views. In 1933, he and his wife, Elizabeth, bought a house and 42 acres of land on Long Island at the mouth of the Kennebec. His painting *From Gilbert Head* evokes the pleasure and glory he and his family found on this island outpost.

Thomas Crotty of Freeport has followed in Etnier's footsteps, choosing to paint quiet coves and pristine coastal prospects, often illuminated by a chill winter light. *Sea Ice* represents the truth of Maine in the off-season, when even the coastal waters freeze up. "Winter in a northern seacoast land is interlude," wrote Gotts islander Ruth Moore. "There is nothing people can do with land like that, bitten four feet deep with frost, secret and uncommunicative under snow"—nothing, that is, except paint it.

Like his friend Crotty, the painter Laurence Sisson prefers overcast conditions. "Maine is gorgeous when it's gray," he once told *Maine Times* critic Edgar Allen Beem. Now a resident of New Mexico, for twenty years or so Sisson worked out of a studio in Boothbay Harbor, and he still returns from time to time to reacquaint himself with the spell of the coast.

In his Maine images, Sisson often devotes a large part of the canvas to the context of an island as viewed from afar: the tidal zones, the rough-and-tumble coastline, the geological elements that at times seem to bubble eerily with volcanic heat—as if we were witnessing the shoreline as it was forming. Sisson's paintings confirm an observation Clinton Trowbridge made in *The Crow Island Journal* (1970). "An island is its coast. It is the tide more than anything else that gives this whole coastline the purity and aliveness it possesses."

CHILDE HASSAM, *WHITE ISLAND LIGHT, ISLES OF SHOALS, AT SUNDOWN*, 1899, OIL ON CANVAS, 27 X 27 IN.
SMITH COLLEGE MUSEUM OF ART, NORTHAMPTON, MASSACHUSETTS

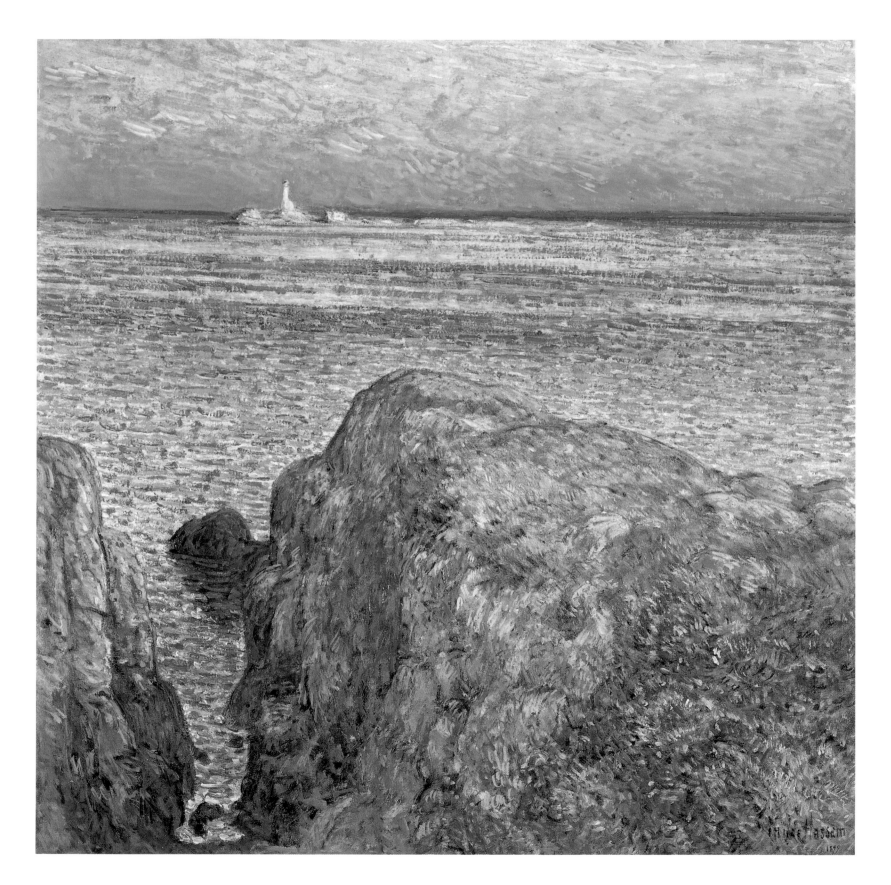

2

This is the most wonderful country ever modeled by the hand of the master architect. The island [Monhegan] is only a mile wide and two miles long, but it looks as large as the Rocky Mountains.

—George Bellows to his wife, Emma, 1911

A N ISLAND means different things to different people; rarely do two artists paint the same view in the same manner. Even when considering the numerous images that exist of Monhegan's Fish Beach, for example, one witnesses a fascinating aesthetic evolution as the scene is processed by Impressionist painters, Ashcan School artists, realists, Abstract Expressionists and others.

With its vigorous and visible strokes of oil paint, George Bellows's painting of Fish Beach stands in sharp contrast to Leo Brooks's depiction of the same location, executed in diaphanous watercolor. Both artists

FREDERICK J. WAUGH, ILLUSTRATION FOR
THE CLAN OF MUNES, BY FREDERICK J. WAUGH
PUBLISHED BY CHARLES SCRIBNER'S SONS, 1916
PENCIL

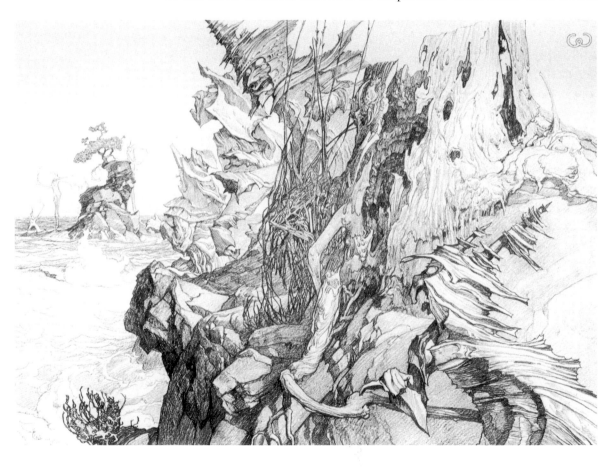

were struck by the daily activities of the fishermen—cleaning fish, hauling dories—yet each drew on an individual aesthetic.

Monhegan is a small island and yet its appeal to artists seems never-ending and marvelously diverse. The great marine artist Frederick Waugh was enthralled by the endless battle between big ocean and fortress shore, yet he also fell under the spell of a less obvious element. "While spending the summer of 1914 industriously painting on Monhegan," wrote his biographer George Havens, "Waugh was suddenly captivated by the curious shapes of tree-roots and the twisted fragments of ancient spruce which he came upon in the forests, tidal pools, and along the rugged shores of this distinctive island."

Out of these "curious shapes" Waugh created the Clan of Munes, a race of tree people who populate Monhegan. They might be considered ancestors of the elves that are said to inhabit the island's famous Cathedral Woods.

Other artists visiting Monhegan have been struck by one or another of the island's landmark geological features. The Russian-born Abraham Bogdanove, for example, painted several views of Pulpit Rock. This distinct shoreline outcropping derives its name from its resemblance to a church pulpit, custom-made for a preacher wishing to address the crashing waves.

More recently, Marguerite Robichaux, one of Maine's finest landscape painters, chose Gull Rock as the subject for one of her distinctive oils. Robichaux spent the better part of five weeks on Monhegan, courtesy of a Carina House fellowship that allows two artists each summer to paint to their heart's content on the island.

In a manner of speaking, Monhegan's dramatic configurations do not allow clichés to occur; in each instance, the artist must recreate the island. Case in point: While many artists have painted the storms that come sweeping over Monhegan, no two are quite the same. Randall Davey's *A Blow at Monhegan* is especially evocative of the turmoil brought on by a good weathermaker. The painting brings to mind the opening lines from Abbie Huston Evans's poem "From an Offshore Island (September Gale)":

Hear now the ocean trouncing off this island,
The under-roar of wind down unfenced sea,
And through chance flaws, like dim lights down a tunnel,
The bell buoy spent with distance.

Not all artists have been drawn to paint such dramatic scenes on Monhegan. Jamie Wyeth, for one, has pretty much avoided this subject matter. He once told writer Martin Dibner, "I've never painted the surf or the sea. A lot of people think: Well, he's moved to an island and it's going to be me-and-seascapes. Well, the sea's *in* the things I've painted, but they're not seascapes."

Wyeth has preferred to focus on, among other things, island dwellings, including those curious "twin houses" built by the painter Rockwell Kent. "My house paintings, on Monhegan in particular, really are portraits," Wyeth told Christopher Crosman, director of the Farnsworth Museum, in 1993. "They're as much portraits of the island as the people are.…Houses take on a whole different aspect on an island, more so than on the mainland."

Wyeth displays the same proprietorship toward Monhegan as his hero, Kent, who made a sustained effort to live an islander's life in the first decade of this century. Kent's paintings pay homage to the people and the landmarks of this "sea-girt island." Like Bellows and Davey, Kent discovered the island through the good graces of his teacher, the Ashcan artist Robert Henri.

Edward Hopper, another of Henri's students, spent the summers between 1917 and 1919 on Monhegan. Besides a group of oil sketches, Hopper made several prints, including *The Monhegan Boat*, which records a scene not unlike what one experiences today on a trip to this outer island. Likewise, the image of lobstermen by Stow Wengenroth might have been drawn on a lithograph stone only yesterday.

N.C. Wyeth, the grandfather of that mighty art family, once wrote from his home in Port Clyde, "Every spot on earth is potential of great interpretation by someone, if he but gives himself up to its underlying beauties rather than to its scenic sensations." Wyeth practiced what he preached in *Maine Headland, Black Head, Monhegan Island*, one of his most powerful seascapes.

The work of Alan Gussow provides a distinct contrast to Wyeth and company—and just goes to prove that Monhegan continues to inspire what one might term varieties of aesthetic experience. Gussow's growth as an artist was indelibly marked by his life on the island, which he first visited in 1949. In the beginning, he was attracted to the picturesque—"lobster pots, fishermen's houses smelling of herring bait in big, brine-filled barrels, and activities of the harbor"—but his interests turned to more elemental material. A piece like *Sea Notes from a Spindrift Morning, Monhegan* testifies to Gussow's lyric response to his surroundings.

Working out of Port Clyde, William Thon has made the voyage to Monhegan by boat on numerous occasions. His firsthand knowledge of

the Gulf of Maine is reflected in powerful marines often accented by the sails of a sloop. In an homage to Thon, poet Philip Booth evokes the intensity of the painter's relationship to his surroundings:

Thon sails light, self-taught
by the ache, dark, and wet of it;
he quarries how it cracks out

at sunset, cut like granite
lighted off islands: the weight,
the winter, the hurricane of it.

3

IF MONHEGAN feels remote to some travelers, Matinicus seems even more isolated, lying as it does on the outer edge of Penobscot Bay, the largest such body of water on the coast of Maine. "Further out than a mainland eye/can see," wrote Philip Booth in his poem "Matinicus."

Bellows visited this island in the early part of the century and other painters have come and gone, but it has never been "colonized" as has Monhegan and other islands. Christopher Huntington spent the summers and falls of 1973 and 1974 on Matinicus. A lifelong admirer of George Bellows, he brought a similar verve and empathy to his island images. He considers the paintings he created there his "graduation thesis"—a major step toward developing a mature style, which would later establish his reputation as one of Maine's outstanding landscape painters.

Moving farther into Penobscot Bay we come to Vinalhaven, where Raphael Soyer, the well-known New York painter of social-realist subjects, spent some time in the 1950s and was moved to paint a number of canvases. These days, the island serves as the headquarters for the Vinalhaven

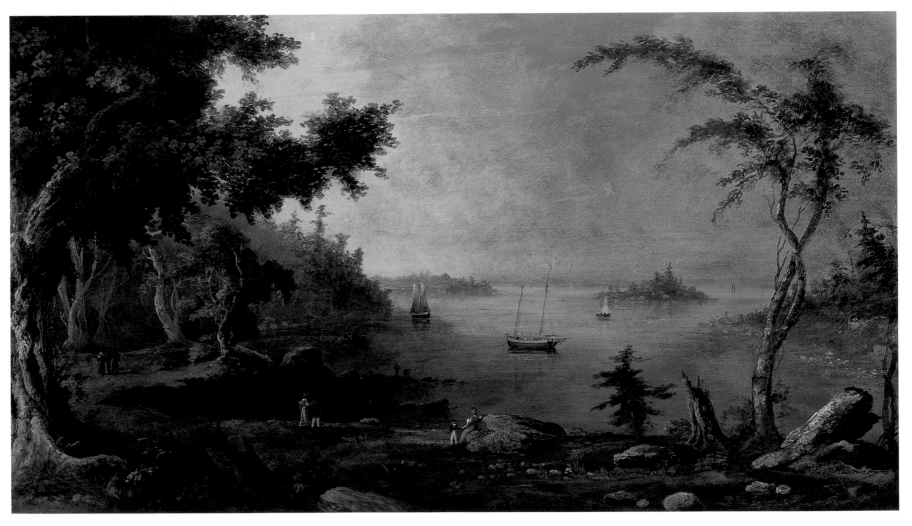

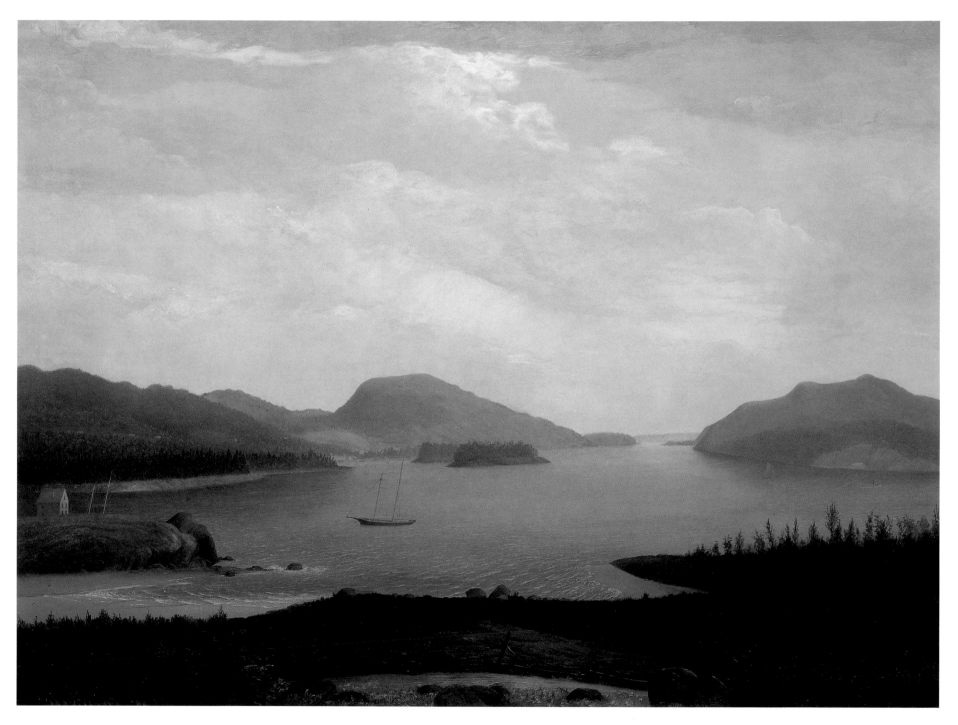

CHARLES CODMAN, *VIEW OF DIAMOND COVE FROM GREAT DIAMOND ISLAND*, 1842

OIL ON PINE PANEL, 37 7/16 x 48 5/16 IN.

COURTESY PORTLAND MUSEUM OF ART, MAINE
PURCHASED WITH GIFTS FROM MISS MARGARET PAYSON, ROGER AND KATHERINE WOODMAN, MR. AND
MRS. J. WESTON WALCH, MR. AND MRS. JOHN RAND, MR. AND MRS. RAYMOND SMALL, MRS. MILLARD
S. PEABODY, MRS. ALEXANDER R. FOWLER, IRIS ALMY, AND ONE ANONYMOUS DONOR; 1973.116.

JAMES EMERY
SOMES SOUND TAKEN FROM SOMERVILLE ROAD, 1886

OIL ON CANVAS, 24 x 32 IN.

COURTESY VOSE GALLERIES OF BOSTON

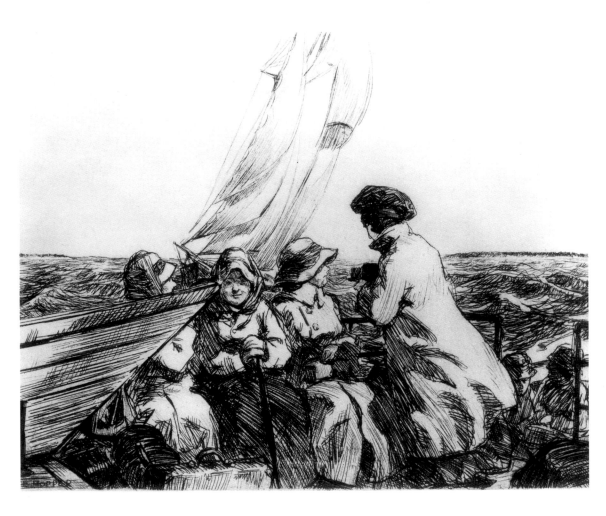

Press, which hosts visiting artists every summer. A number of them, including Susan Crile and Yvonne Jacquette, have based particular works on island motifs.

In the poem "Island Born," Harold Vinal, whose ancestors settled Vinalhaven, invokes the special qualities associated with an offshore birth:

> My mother bore me in an island town,
> So I love windy water and the sight
> Of luggers sailing by in thick moonlight;
> I wear the sea as others wear a crown.

Eric Hopkins is one of a handful of artists who can claim lifelong Maine island kinship. Although born in Bangor, he was brought up on North Haven, across the Fox Island Thorofare from Vinalhaven, and comes from a line of Hopkinses that reaches back to the day of schooners. In fact, the gallery where he shows his work on North Haven was once upon a time the family ship's chandlery.

In the early 1980s, Hopkins discovered what has since become his signature subject matter: the islands as viewed from on high. "With my aerial views," said the artist, "I want to show the interactions of islands, ocean and sky. I'm talking another point of view—an all-encompassing view—where boundaries are edges of trees, land, water, horizon and sky rather than fences, roads and houses." He often works from video footage taken from a plane.

Hopkins's islands appear to move across the horizons, as if they were alive. Some lines from Elizabeth Bishop's poem "North Haven" evoke this quality:

The islands haven't shifted since last summer,
even if I like to pretend they have
—drifting, in a dreamy sort of way,
a little north, a little south or sidewise,
and that they're free within the blue frontiers of bay.

By her own account, Brita Holmquist has lived on an island in Penobscot Bay "all the summers" of her life. Looking at her brightly hued images of Islesboro and environs, one admires the sunny palette and the expressionist verve, with sea and clouds often rendered in unusual configurations and patterns. *Rising from the Beach* depicts Seal Island, which lies between Islesboro and Northport on the mainland. Holmquist executed this color drawing from a 16-foot Boston whaler as her daughter chauffeured her around the bay.

Fairfield Porter expressed a similar dedication to Great Spruce Head Island, his base of painting in Maine for much of his life. Set near the middle of Penobscot Bay, surrounded by other islands large and small, Great Spruce Head provided visual nourishment to Porter and his artistic family.

Among Porter's finest Maine canvases are those devoted to the wildflowers that flourish in the meadows and along the shores. His passion for the diverse flora can also be found in his poems. Take these lines from "Great Spruce Head Island":

> …the roses and hawkweed
> Will last with the meadows until the gulls return and the fish hawks
> in the wind
> And the fog dragged in by the water on the flooding tide
> And warblers in the alders and the white-throat on the hill and
> wild berries
> And the tadpole shape of the island rising highest in the bay.

THANKS to their isolation, Maine islands are considered by scientists to be excellent laboratories for the study of a variety of flora and fauna. Many islands serve as stopping places for birds along the Atlantic flyway. If you visit Monhegan in October, you're bound to share the island with a passel of birdwatchers, binoculars aimed every which way. In recent years, puffins, terns and other sea-bird species that were wiped out around the turn of the century have been successfully reintroduced on such islands as Petit Manan and Eastern Egg Rock.

Artists, too, have been attracted to this wildlife. In a marvelous series of oil sketches made on Southern Island off Tenants Harbor, Jamie Wyeth captures the dark spirit of the ravens and crows. He depicts a more domesticated creature—a ram—in his painting *The Islander*. Since the days of the first settlers, sheep, cattle and other livestock have been set to graze on these floating pastures.

Dahlov Ipcar, the acclaimed children's book writer, illustrator and painter, lives in Georgetown, on Long Island, where she creates her wondrous images of all manner of animals. In *Outer Basket Ledge*, she depicts one of the low-lying rocky outcrops in the water where the seals haul themselves out to sun. Her painting brings to mind the poem "Maine" by Brooke Astor, a summer resident of Mount Desert Island:

With clumsy strength the seal climbs on the rock
then lies on its back waiting for the tide to cover it.
Is it discipline that keeps it on the narrow ledge
or is it anticipation of voluptuous delight?

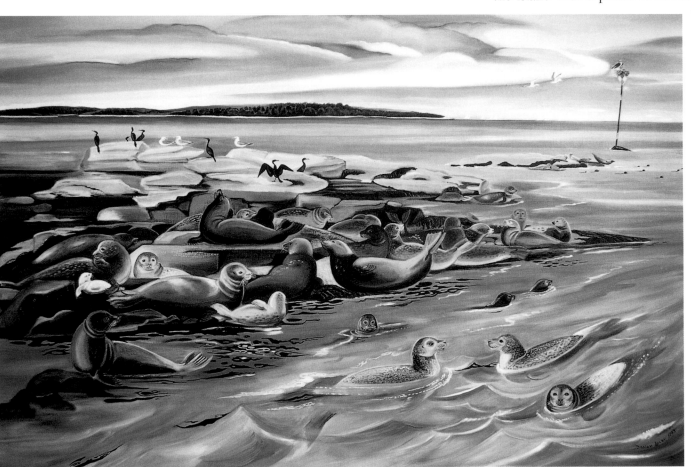

DAHLOV IPCAR, *OUTER BASKET LEDGE*, 1983
OIL, 48 X 72 IN., COLLECTION OF MR. C. DAVID O'BRIEN

A number of Maine islands have taken their names from the animals that frequent them; according to the *Maine Almanac and Book of Lists*, there are twenty-six Bear Islands in the state. James Carpenter painted one of several Fox Islands, this one lying off of Georgetown, where he and his family had a summer home. Known for his scholarship in art history and for the role he played in creating the Colby College Art Museum, Carpenter was also an accomplished watercolorist, with a special love of coastal views.

Deer Isle derives its name from those white-tailed creatures that frequent the edges of meadows. One of those peninsular locations, accessible via a precipitous bridge, Deer Isle has attracted many artists over the years. John Marin and William and Marguerite Zorach arrived before 1920, William and Emily Muir in the late '30s, William Kienbusch in the early '40s, Karl Schrag in the '50s—all of them part of a remarkable procession of artists.

The beauty of the surroundings in Stonington on Deer Isle nurtured Marguerite Zorach's art in a most profound manner. The painting *Stonington, Maine* exemplifies her post-Cubist style, one marked by stylized rhythmic shapes. In a related modernist vein are the watercolors of William Muir. His *The Quarriers* portrays a group of stoneworkers on Crotch Island in Penobscot Bay.

Later in his life, William Kienbusch kept a boat in Stonington, which he rowed out to the islands in Penobscot Bay, especially in the autumn. He also hitched rides with lobstermen, who would drop him off on a remote island where he would spend the day experiencing the isolation. He described these trips in terms of a dream.

Kienbusch often stayed with his close friend Francis Hamabe at his home in nearby Blue Hill Falls. A superb graphic artist whose work frequently appeared on the cover of *Down East* in the early years of that magazine, Hamabe brings a stylized aesthetic to bear on his image of kayakers approaching Crotch Island.

Karl Schrag and his wife, Ilse, bought a farmhouse on Deer Isle in the late '50s. He was already a devotee of Maine islands, having spent summers on Chebeague, Vinalhaven and Great Spruce Head, yet Deer Isle proved best suited to his expressionist tendencies. Schrag loved the contrasts—"the darkest woods, the most luminescent distances"—and he was content to return to the same motifs every year: the unruly islands, a golden meadow, moonlit spruce. Writing of his friend's work in 1984, the late Bernard Malamud observed that the artist "handles night subtly yet with daring. His moons ride high and spread light radiantly." *Island Night*

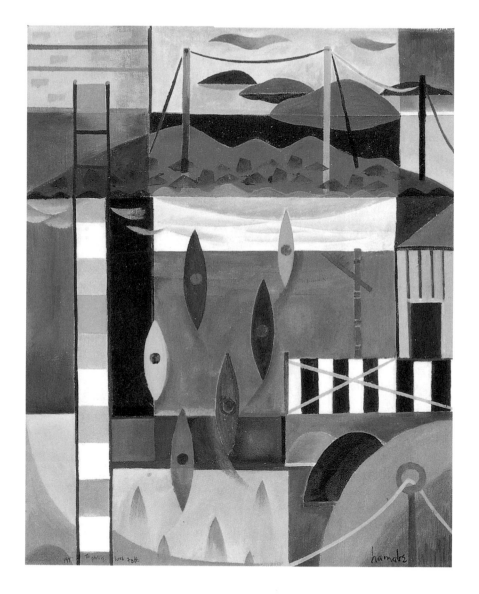

FRANCIS HAMABE, *KAYAKS PADDLING TO CROTCH ISLAND*, 1997
OIL, 16 X 20 IN., COLLECTION OF THE ARTIST

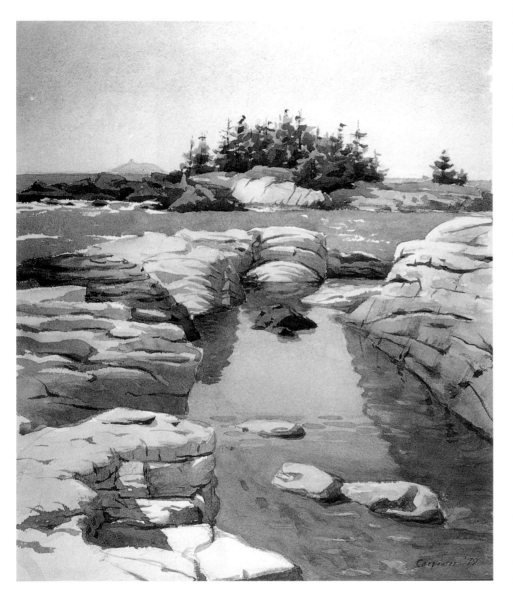

She would have also passed by the barn studio of Dorothy Eisner, who in the '70s and '80s was painting up a storm, creating a body of work marked by lively brush strokes and a refreshing esprit.

Eisner's next-door neighbor was William Kienbusch, who bought an island home in the 1960s and set up a summer workplace. Today, Kienbusch's nephew David Little carries forth the artistic lineage, paying tribute to the island in his painterly oils.

Neighboring Little Cranberry supports an equally active colony of artists. Some are home-grown like Dan Fernald, who is a seventh-generation lobsterman, while others, like Henry Isaacs, return year after year. Fernald and Isaacs prefer a near-Fauvist palette that heightens the island's color scheme.

James Linehan only recently discovered Little Cranberry's charms. He is especially adept at rendering the cool northern light that accompanies a late summer or early autumn day. His canvases convince one of the truth of something Nathaniel Hawthorne once said: "Methinks an island would be the most desirable of all landed property, for it seems like a little world by itself; and the water may answer instead of the atmosphere that surrounds planets."

7

Here is the place to see it all, and to drain the full cup of delight; not a standpoint, but a sailing-line just beyond Baker's Island: a voyager's field of vision, shifting, changing, unfolding, as new bays and islands come into view, and new peaks rise, and new valleys open in the line of emerald and amethyst and carnelian and tourmaline hills.

—Henry van Dyke, *Days Off and Other Digressions*, 1907

MANY KNOW that the best place to view Mount Desert Island is from the Cranberries. That distant range—"nine hump-backed hills," as novelist Rachel Field described them in *God's Pocket* (1934), resembling "sea-bound whales"—serves as a spectacular backdrop to many a view. Looming in one picture, receding in another, the island seems at times to accentuate the curve of the earth.

Of course, artists have found spectacular vistas on Mount Desert itself. Take James Emery's painting of Somes Sound, the only natural fiord on the eastern coast of America. This view goes well with a passage

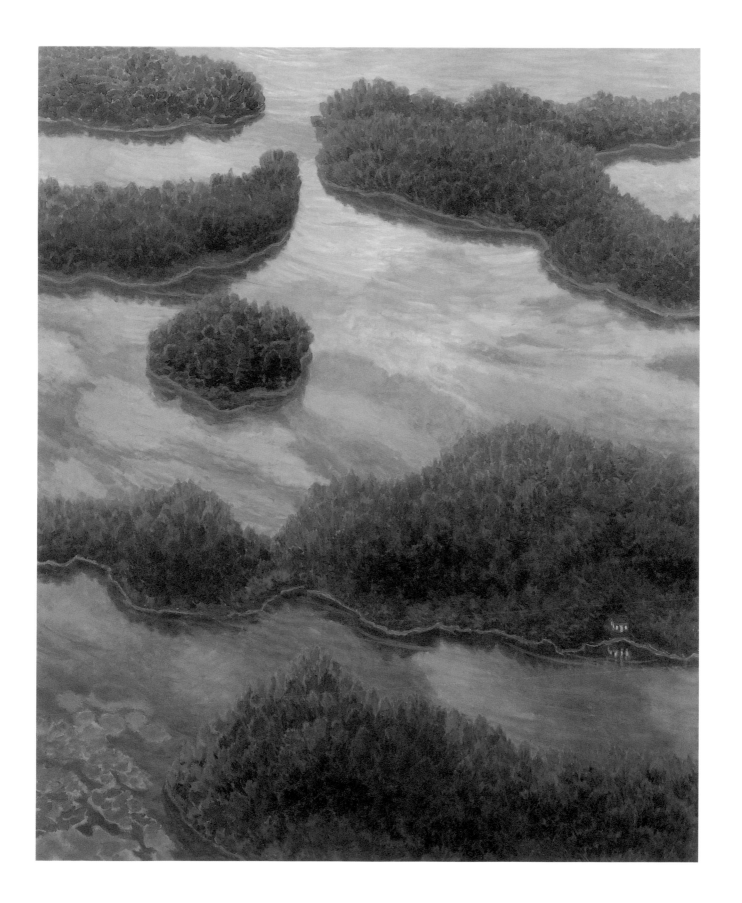

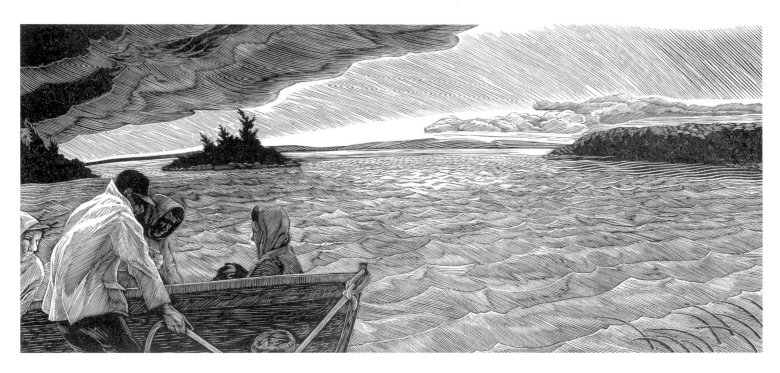

SIRI BECKMAN, *APPROACHING STORM*, 1996, WOOD ENGRAVING, 4 1/2 X 10 IN.,
FROM THE BOOK *A WEEK AT THE LAKE*, PUBLISHED BY OUT OF THE WOODS PRESS, 1997, COLLECTION OF THE ARTIST

from Ellen Chase's novel *Silas Crockett* (1935):

> And on alternate nights when the *Matinicus* lay over in her Mount
> Desert port, he [Reuben Crockett] smoked his pipe,...and won-
> dered if Java Head and the peaks beyond Rio and even the har-
> bour of Sydney, which his father had seen, were actually more
> beautiful than the tumbling Mount Desert hills rising darkly into
> the evening sky or growing blue as the dawn broke behind them.

Carroll Sargent Tyson painted on Mount Desert Island for over fifty
summers. A friend of Claude Monet, Tyson was an American Impres-
sionist of the first rank, as witness his rendering of Bass Harbor Marsh.
On the occasion of a retrospective in 1974, Louis C. Madeira IV provid-
ed a delightful description of his father-in-law's working habits:

> [Tyson] would...leave by dawn to be set up on his day's painting
> project by the time of the best light. He drove a Model A Ford
> runabout to enable him to go through rough terrain....The easel
> stuck out of the rumble seat and he was always accompanied by a
> nasty mongrel female spaniel who bit any potential kibitzer.

From the Isle of Skye in England to Grand Manan in Canada, islands
run through the life and work of Frank Metz. Metz has been coming to
Maine for almost fifty years; since 1990, he has been a summer resident
of Pretty Marsh on the "quiet side" of Mount Desert Island. He might
agree with an observation made by Mary Wyckham Bond in "Pretty
Marsh in June":

> Living close to the soothing rhythm of a ten-foot tide rewards you
> with the feeling that something orderly is going on all the time,
> something you can rely upon.

Master realist Richard Estes set up a painting studio overlooking
Northeast Harbor in the 1970s. Known for his extraordinary renderings
of urban views, Estes has recently begun to paint his Maine surround-
ings. An exquisite series of small oils from 1996 are based on trips among
the Cranberry Isles.

Another artist with realist inclinations is Joellyn Duesberry, who has
been painting in the Mount Desert Island area for almost twenty-five
summers. A favorite motif for her has been Hall Quarry, on the shore of

Somes Sound. The abandoned quarry makes for fascinating studies in shapes where the stoneworkers cut the granite into great blocks, many of which were shipped to Boston, New York and elsewhere.

One of the most recent artists to settle on Mount Desert Island is Robert Pollien. Chosen as the first Acadia National Park artist-in-residence in 1992, Pollien caught the bug and eventually moved with his family to Town Hill. On painting expeditions around the island, he has been drawn to some of the more remote and rugged places.

Pollien and company might echo the sentiments of historian Samuel Eliot Morison regarding the merits of this island. "Mount Desert is not merely an island," he wrote, "it is a way of life to which one becomes addicted; and if we are permitted in the hereafter to enter that abode where the just are made perfect, let us hope that it may have some resemblance to Champlain's *Isle des Monts Déserts*."

8

An island that is mostly a field is a rarity on this coast. The picture postcard Maine islands look like porcupines, so thickly do the spruces and balsam quill their backs.

—Clinton Trowbridge, *The Crow Island Journal*, 1970

AS ONE HEADS farther down and east along the coast of Maine, the islands seem to become wilder and woollier. The Porcupines, lying off of Bar Harbor in Frenchman Bay, are a case in point: They earn their name in part by virtue of their bristly appearance.

On a visit from her home port of Gloucester, Massachusetts, Eleanor Levin painted Bald Porcupine on a day when a fog had overrun the region, playing games of hide and seek with the islands. A statement made by O.B. Bunce in *Picturesque America* (1872) proves relevant to Levin's vision: "The fog pictures at Mount Desert are by no means the least interesting feature of this strange shore."

Bald Porcupine also worked its magic on artist Michael Lewis, who stayed at Compass Harbor in the mid-1980s. His first plunge into landscape painting occurred in this setting; over a two-year period he produced oil studies that led to the atmospheric turpentine-wash pictures that have gained him acclaim in recent years. Among his admirers is Konrad Oberhuber—esteemed art historian, former curator at the Fogg

Art Museum and current director of the Albertina Museum in Vienna—who visited Lewis at Compass Harbor and, in so doing, ended up in one of his paintings.

Beyond the Porcupines lies Ironbound Island, where painter Dwight Blaney hosted the master watercolorist John Singer Sargent on several occasions in the early 1920s. Acclaimed for his portraits of the well-to-do, Sargent painted his friend Blaney in the act of sketching on the shore of Ironbound. According to art historian Lloyd Goodrich, this and other watercolors from these visits show Sargent "at his least formal—far more sympathetic, both humanly and artistically, than his commissioned portraits of the rich and fashionable."

In the last years of his life, Maine-born Marsden Hartley took up residence in an abandoned chicken brooder shack in the tiny seacoast town of Corea. Hartley had lived at Vinalhaven for a time and had painted his share of Maine islands. From Corea, he had window views of the shaggy downeast archipelago—those isles that seem to drift on the edge of the world.

Not much farther down the coast, Hartley's friend John Marin settled at Cape Split, a promontory jutting out from South Addison, where he worked in the 1930s and 1940s. Marin loved the untamed quality of this part of Maine; his watercolors and oils often respond to the unchecked elements.

In more recent years, Sara Weeks Peabody has explored this stretch of coast, working out of Corea and from her studio in Northeast Harbor on Mount Desert Island. Her splendid view of blueberry barrens overlooking the coast and islands recalls something Marin wrote in a letter in 1933 from Cape Split:

> There be miles and miles of blue berry farms—there be berries of all descript—and Clams—Clams—Clams—and Lobsters for little money—Yep there's lots here for little—and one don't know what's going on in the rest of the country—and one gets so one worries very little about all that.

Another relatively new arrival to this part of the coast is Nina Jerome, who in the last three or so years has been painting the landscape around the Bickford Point area in Addison and across the water toward what she calls "the Jonesport Archipelago." An image like *Earth, Air, Water, and Light*, in title and in truth, sums up the wonderful elemental quality one experiences in a part of Maine still overlooked by "summercators."

Last but not least, Tom Paquette found a severe winter beauty on

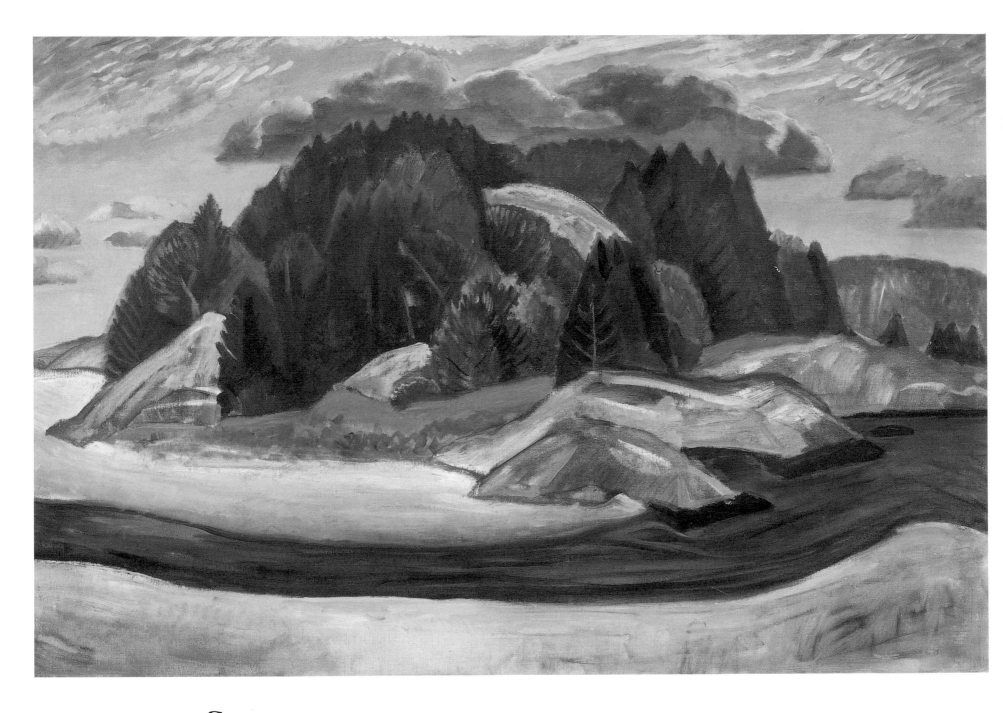

Scarce marked on the map, the island flew no flag,
But lay unwanted as a prickly burr
On silk, in the lap of tides,
Growing at center forests roped with vines
Where whirlwinds circled and high walls of surf
Pressed inland, out of bounds.

Here sea-birds built their nests,
The shy blue heron bringing silvery fish
To raucous throats, and diving osprey
With a double task
At hatching time.

—Hortense Flexner, from "Happy Country"

Great Wass Island, a preserve that lies off the Maine coast way down east. Like that Ultima Thule described by Edgar Allan Poe in *The Narrative of Arthur Gordon Pym* (1837), this island under its coat of snow and ice has an end-of-the-world quality—as if we had reached a Maine coast Arctic.

9

It seems that Old Man God when he made this part of the Earth just took a shovel full of islands and let them drop.

—John Marin to Alfred Stieglitz, July 1, 1919

AT TIMES, THE ISLANDS of Maine seem limitless. Indeed, thanks to a sophisticated mapping technology called Geographic Information Systems (GIS), at last count Marin's "shovel full" comes to around 4,500. As a writer for *Down East* magazine reported it, "The islands of the Maine coast seem to be multiplying—like rabbits."

Despite their great number and the isolation that many of them afford, the islands of Maine have not avoided the pressures of encroaching civilization. In recent times, many have faced daunting demographic fluctuations and development issues.

Artists, among others, have remarked upon these changes. Returning to Monhegan in the late 1940s, Rockwell Kent was shocked by what he found:

> From a remote island settlement of fishermen and their families, visited in summer by occasional artists and such city folks as loved the island's rocks and headlands and its isolated, simple life, it had become a Down East Provincetown that sprouted cottages as though some careless hand had spilled their seed.

By contrast, some islands, like Frenchboro and Cliff, have suffered from declining population. Both communities have found it necessary in recent years to launch recruiting programs to attract new residents. "Cliff Island, Maine, Is Looking for a Few Good Families..." read the cover of *Yankee* magazine in March 1997. As historian Hugh Dwelley of Little

Cranberry wrote recently with concern, "Our island is one of only fifteen year-round communities remaining off the coast of Maine—there were some 300!"

Other Maine islands have been the focus of intense battles related to preservation. Most recently, Sears Island was the center of a fight over whether or not it should become a port for oil tankers. This fight has gone on for years. Back in the 1960s, Buckminster Fuller, visionary architect and summer resident of Bear Island, sent a telegram to Senator Edmund Muskie deploring the proposed construction of a refinery on Sears Island:

> It is even more ignorant and irresponsible
> To surface and transport oils
> Of Arabia, Venezuela, Africa and East Indies
> To refineries and storages on the coast of Maine,
> Thus putting into ecological jeopardy
> One of the world's
> As yet most humanly cherished
> Multi-islanded, sea coast wildernesses.

Thankfully, there are many individuals and organizations that have made it their mission to preserve the Maine islands. The Island Institute, Maine Audubon, the Nature Conservancy, the Maine Island Trail Association, College of the Atlantic, Maine Coast Heritage Trust—these and many other coastal groups have gone out of their way to establish a Maine island ethic.

Artists play a role in the preservation of islands. The Wyeths, Neil Welliver and many others support conservation efforts with their art. And by the very act of limning islands, all of them help preserve the landscape, recording views for posterity.

"There is still something sublime, yet primal, about Maine that presents artists with remarkable inspiration and opportunity," artist Thomas Crotty has stated. The islands cast an especially strong spell, offering those qualities that drive men and women to artistic distraction. Many of them would second an observation Robert Louis Stevenson once made: "Give me an island above all things in this world."

MARGUERITE ZORACH, *MAINE ISLAND*, C. 1945

OIL ON CANVAS, 20 X 30 IN.

PRIVATE COLLECTION

COURTESY KRAUSHAAR GALLERIES, NEW YORK

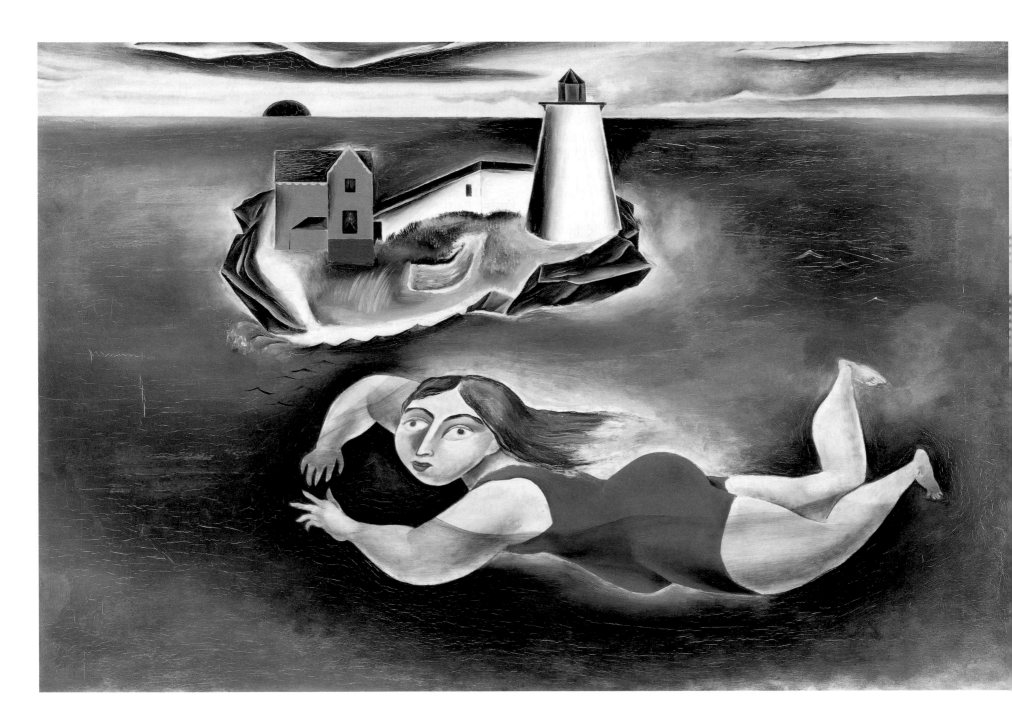

YASUO KUNIYOSHI, *THE SWIMMER*, C. 1924, OIL ON CANVAS, 20 1/2 X 30 1/2 IN., COURTESY COLUMBUS MUSEUM OF ART, OHIO, GIFT OF FERDINAND HOWALD

MARGUERITE ZORACH
STONINGTON, MAINE, c. 1920
OIL ON CANVAS, 24 x 20 IN.
PRIVATE COLLECTION

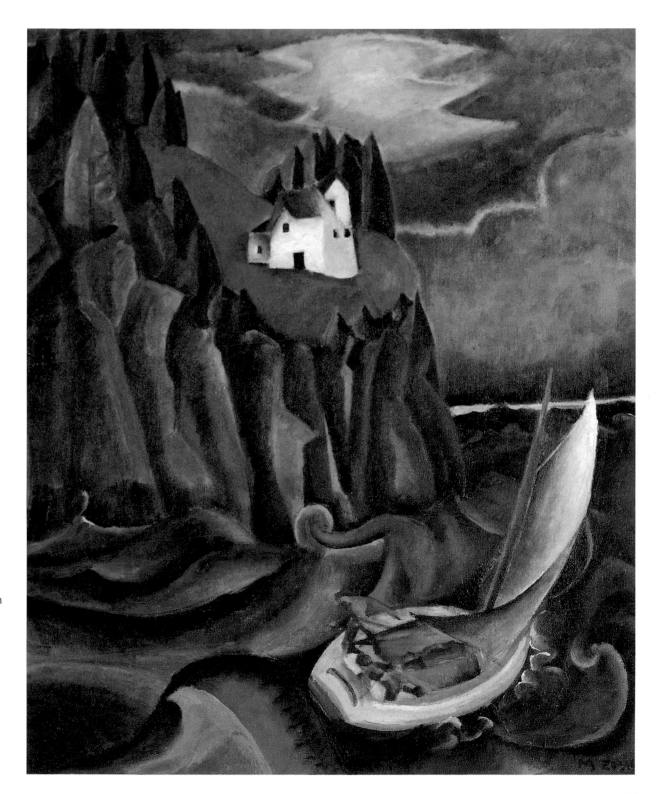

The Lighthouse

If the path to the lighthouse
runs through beach grasses
walked upon in another time
sharp-edged blades cutting the flesh
sand displaced under each footfall
if the ocean breaks into hollow crevices
scoured out of resistant granite
falls back and gathers to break again
do we come in the morning's splendor
to replay our haunting memories
or do we seek this perpendicular monolith
relic of uncountable nights flashing a resolute beam
to confirm that each storm arriving to assault
land's end, divides, as water flowing
continually makes room, and the lighthouse stands?

—Julia Bates

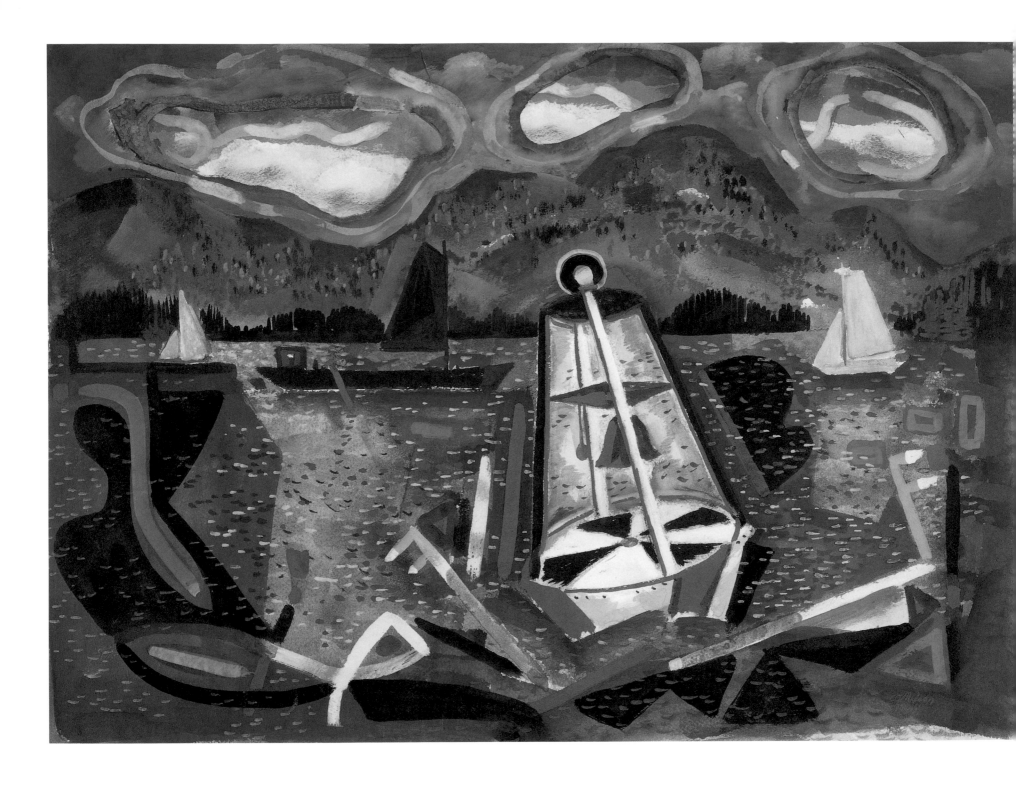

CARL G. NELSON, *THE BUOY*, 1946, CASEIN, 20 X 25 IN., COLLECTION OF H. RICHARD AND ANN VARTABEDIAN, COURTESY GLEASON FINE ART

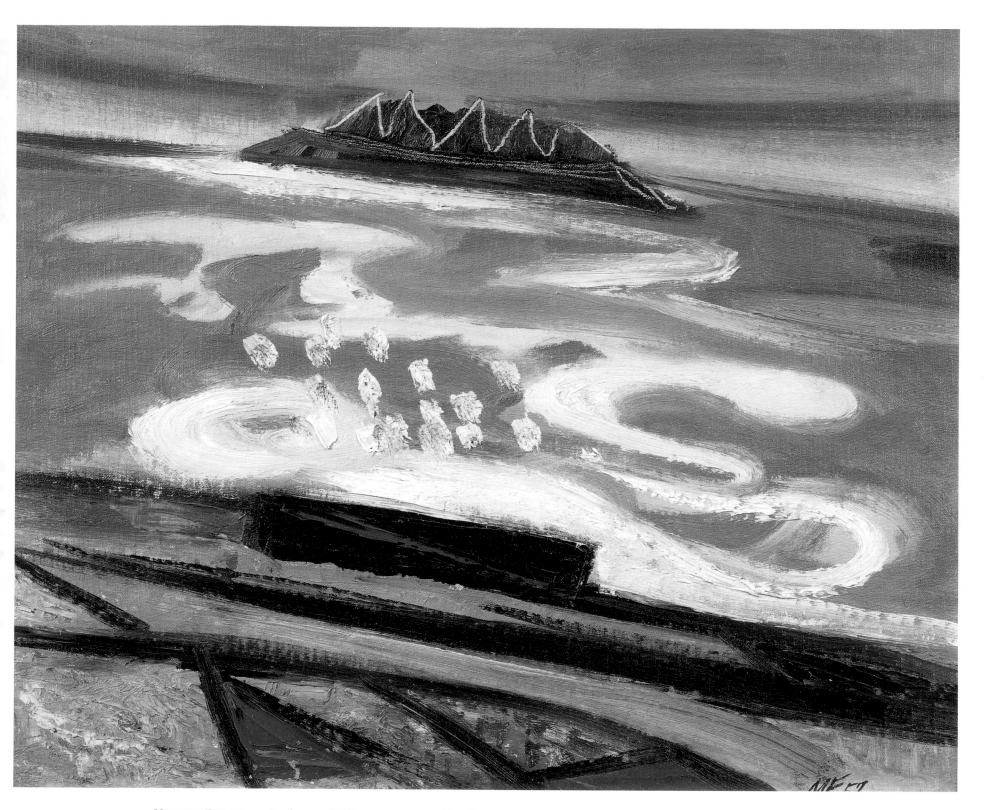

MAURICE FREEDMAN, *Nor'easter*, 1957, OIL ON BOARD, 16 X 20 IN., PRIVATE COLLECTION, MAINE, PHOTOGRAPHY BY ED WATKINS

Behold this favored and bedeviled isle,
 The farmer's bane, the mariner's despair;
'Tis Whittier's "grey and thunder-smitten pile."
 'Tis seven mountains rising gaunt and bare.
Yet seen in June 'neath nature's fleeting smile
 A first explorer gives his thankful prayer:
"There came a scent from off these shores," he wrote,
 "Like that which fills a garden"—end the quote.

—August Heckscher, "Letter from a Maine Island"

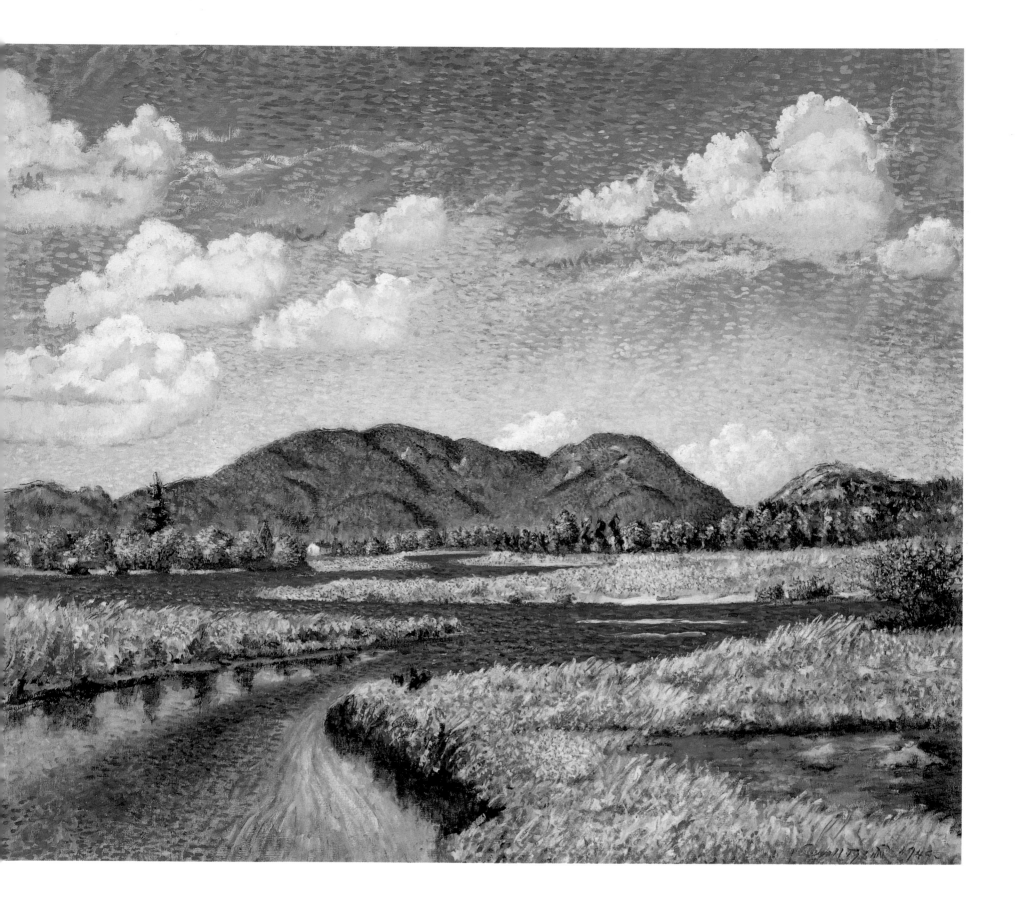

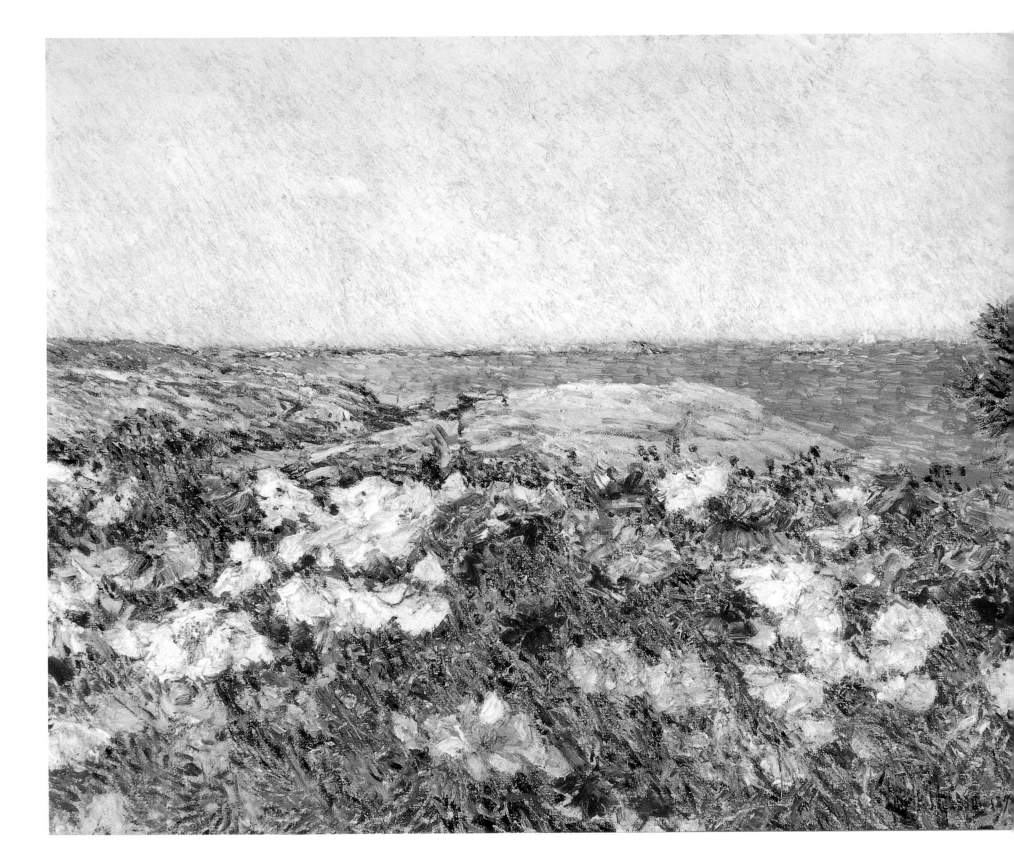

The eternal sound of the sea on every side has a tendency to wear away the edge of human thought and perception; sharp outlines become blurred and softened like a sketch in charcoal; nothing appeals to the mind with the same distinctness as on the mainland, amid the rush and stir of people and things.

—Celia Thaxter, *Among the Isles of Shoals*, 1873

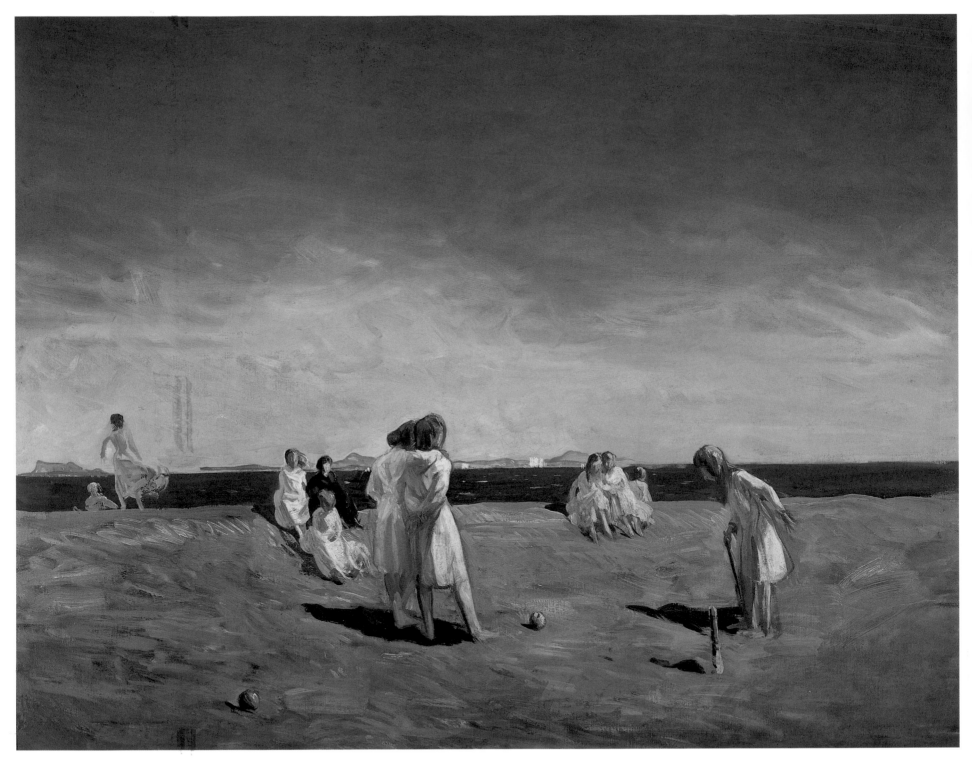

ROCKWELL KENT

CROQUET (THE BEACH PARTY), C. 1906–7

OIL ON CANVAS, 34 X 44 IN.

PRIVATE COLLECTION, COURTESY DAVID FINDLAY, JR. FINE ART

ATTRIBUTED TO ROCKWELL KENT

BLUE MONDAY, C. 1905–7

OIL ON CANVAS, 28 X 38 1/4 IN.

COURTESY CAMPUS COLLECTIONS, BROWN UNIVERSITY

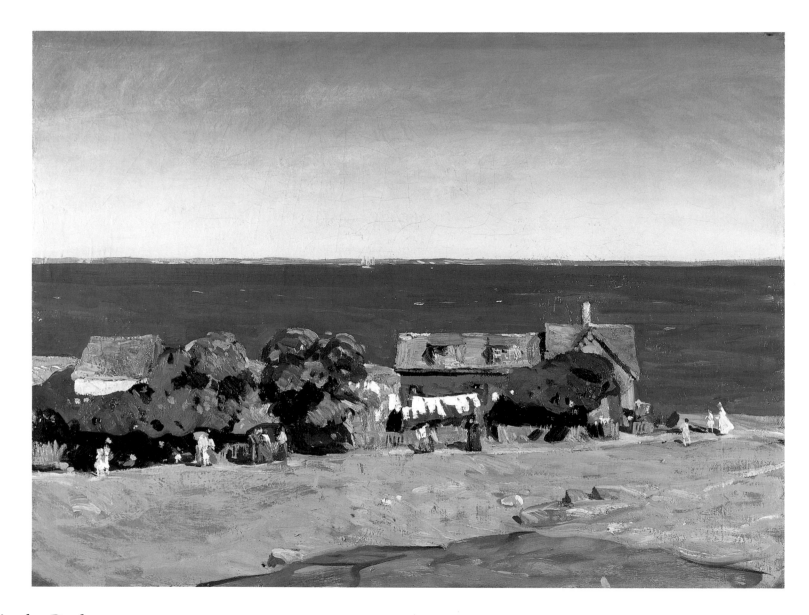

Islanders in the Dusk

In the hour or so before pure night arrives
islanders leave the house lights off,
or some do, as the stand of backyard alders
becomes a mass even the full moon
has trouble penetrating. Words

travel far through island air,
through windows left wide to dialogue:
brothers on bikes, late croquet players,
the couple who missed the last mailboat and must
stay the night. Islanders in the dusk

listen in; their home's darkening looks
keep them safe from unexpected visitors.
Across the sitting room they watch each other
disappear into sofa, captain's chair,
little exchanged beyond occasional

identification: the new lovers next door,
an artist returning from her favorite cove.
Until one of them lights the corner lamp
out of impatience, fear or simple
necessity of food, book and bed,

the islanders will let darkness over-
run the windowsill with a stealth
long respected, their way of welcoming a guest
whose gift, house-chilling, descends
from another, darker island to the west.

—Carl Little

37

The Waterwalkers

Silent as sin, the heat hangs sultry
in shadows where wingbeats
invade the nested shade.

Summer people set white sails and call
the clouds away. They lay their skins
on the hot sand like drying cod.

Lapped waves lift the tern's cry
as water cascades the island:
a long song of spruce and balsam.

Beyond the magic of meadows
on the forested side of the island,
lady's slippers hide in reindeer moss.

Homes are close and remote together:
rimmed in salt, in fish, in the tide.
Idle as islanders' gossip,

ghost trees grow new life there
felled by too many winters—
windworn, crowded together.

Now they wear moss green velvet,
and recline among the ferns.
The sun glints into the forest,

its light like water, moving.
The rocks' ledgy ridges
hold ruffles of purple peas,

ochre lichens in the folds,
bathed and owned by the sea.
All Spring, women sit knitting

heads for the lobster traps
as children paint the markers,
looking out to sea and graves of ships.

With eyes blue as clintonia berries,
they can almost see the waterwalkers:
souls of lost fishermen

whose widows walk where the wind flutes,
keeping the water's voice
always lonely in their ears.

—Alice Williams

GEORGE BELLOWS
FISHING HARBOR, MONHEGAN ISLAND, 1913–15
OIL ON CANVAS, 26 x 38 IN.
COURTESY JORDAN-VOLPE GALLERY, NEW YORK

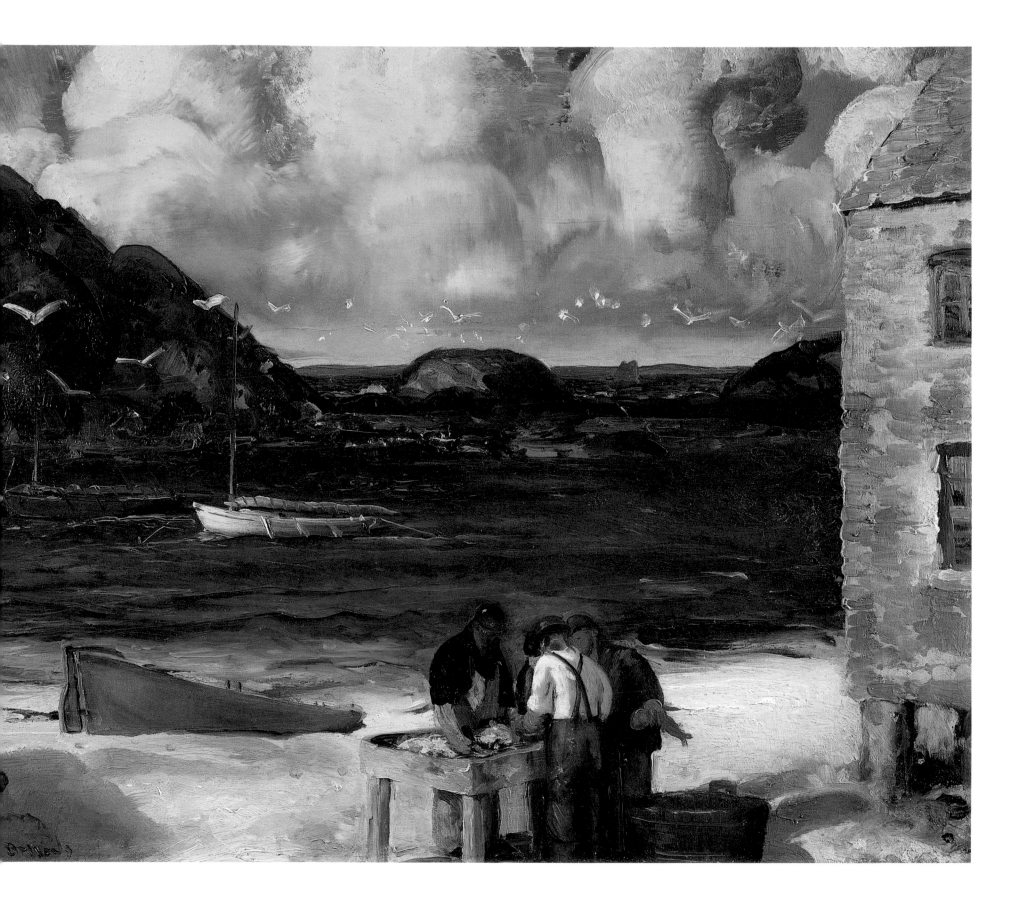

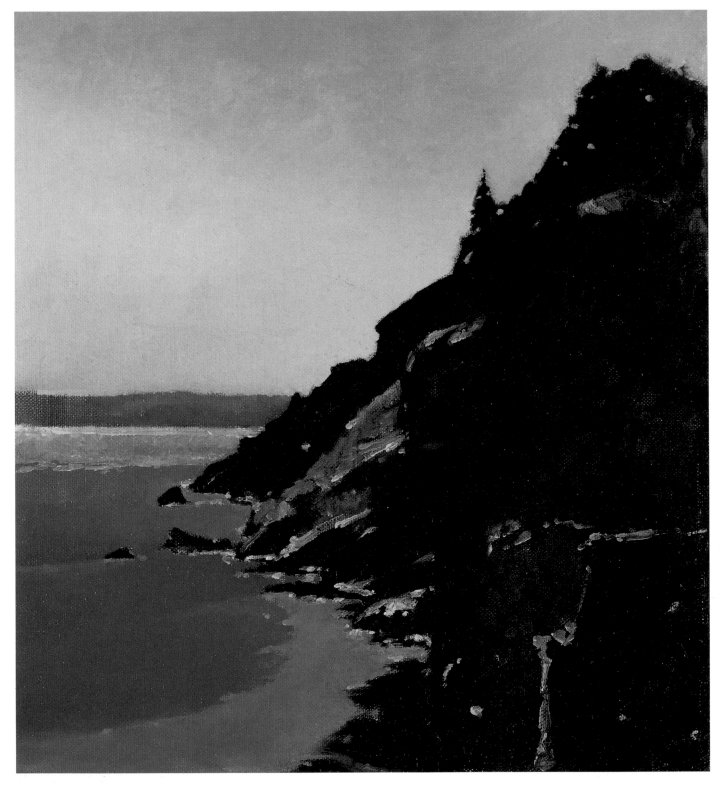

Mt. Desert has almost all the characteristics of an island. It has definite boundaries. I can travel only so far before I simply run out of Mt. Desert Island. I can't get lost on it. I always come out somewhere if I walk long enough.

—Gunnar Hansen, "Mt. Desert Island?"

ROBERT POLLIEN, *HUNTER'S BEACH*, 1995, OIL ON LINEN, 11 X 12 IN.

COLLECTION OF THE ARTIST, COURTESY O'FARRELL GALLERY, BRUNSWICK, MAINE

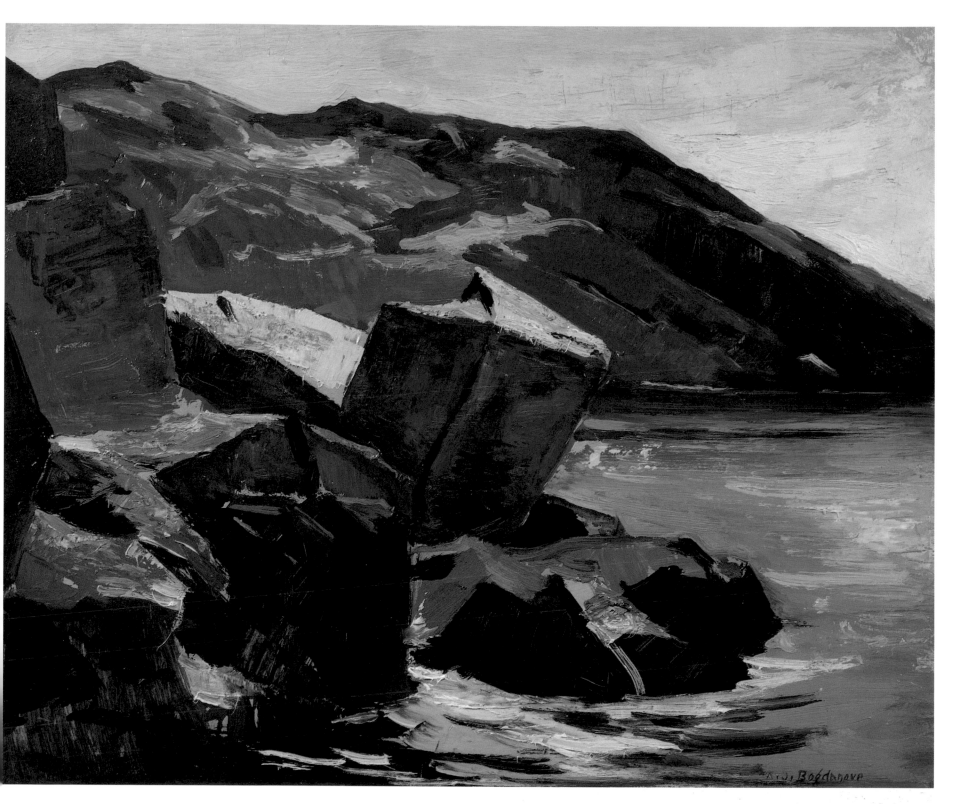

ABRAHAM BOGDANOVE, *THE PULPIT*, 1987, OIL ON MASONITE, 20 X 24 IN., COURTESY SPANIERMAN GALLERY, LLC

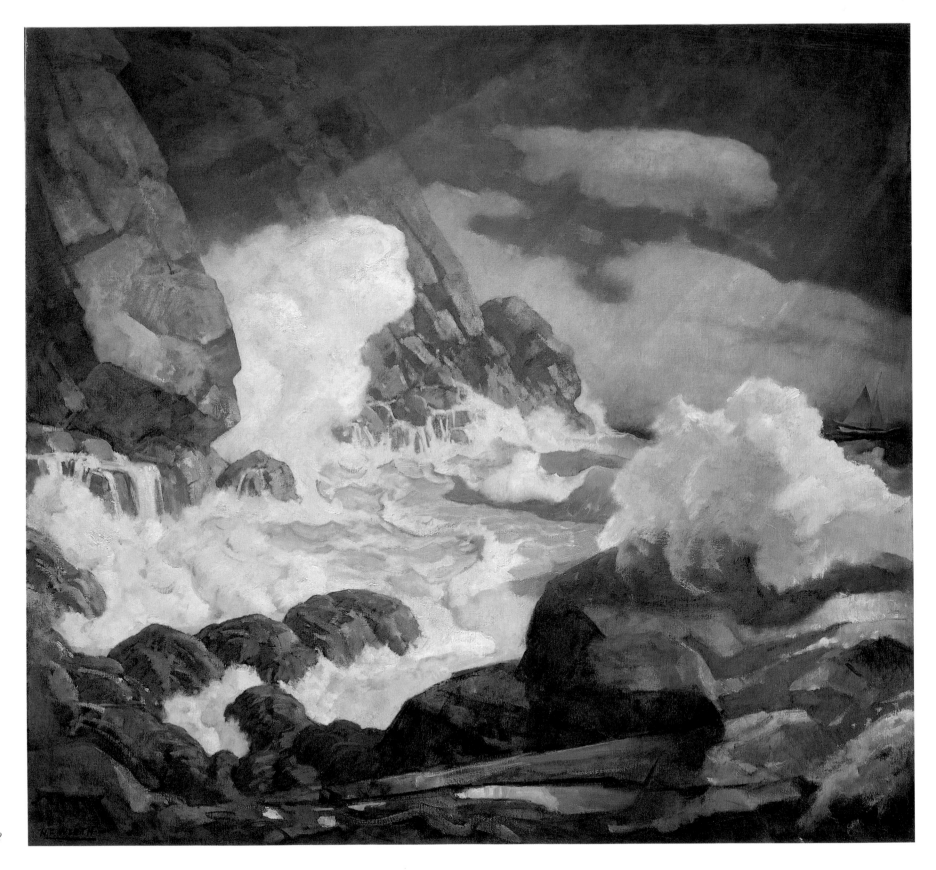

At four in the morning, while the stars were still shining, our boatman, remorseless as old Charon himself, called to us from the foot of the stairs to turn out. The wind was light but fair for Monhegan. So once more we groped our way out among the slippery rock-weed, which threatened at every step to trip us up, down to the landing-place, from which we presently glided out again upon the open sea.

With sails and oars we gradually worked our way up to the island by the middle of the forenoon. For me, its every secret nook and cranny—gray headland or tuft of woods—held a mysterious charm like to that surrounding some antique sea-hold of song or story; for whether the Viking bold or men who sailed with Frobisher or Drake were the first to set foot on Monhegan, it is the vanishing-point down the long vista of time, the haven wherein we dimly discern the first discovery ship at anchor.

—Samuel Adams Drake, "Monhegan on the Sea," from *The Pine Tree Coast*, 1891

N.C. WYETH, *MAINE HEADLAND, BLACK HEAD, MONHEGAN ISLAND*, 1934, OIL ON CANVAS, 48 1/4 X 52 1/4 IN.
COURTESY FARNSWORTH ART MUSEUM, ESTATE OF MRS. ELIZABETH B. NOYCE, PHOTOGRAPHY BY MELVILLE D. MCLEAN

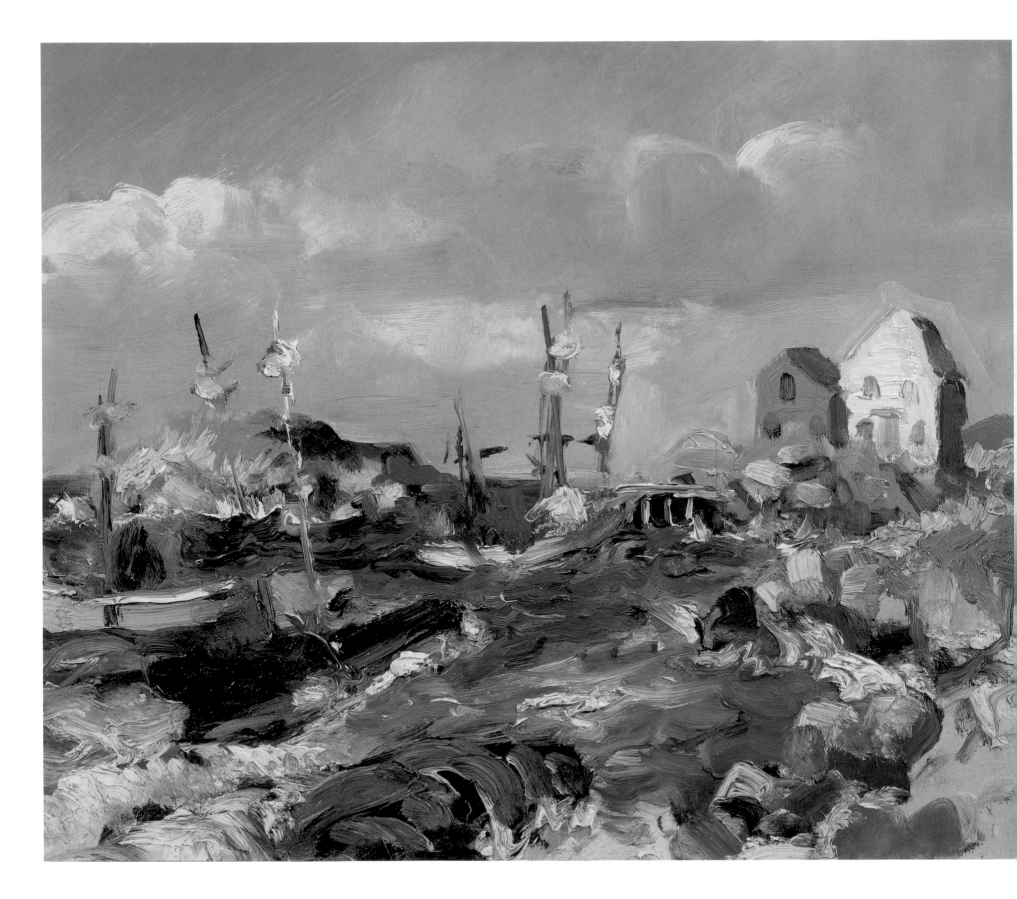

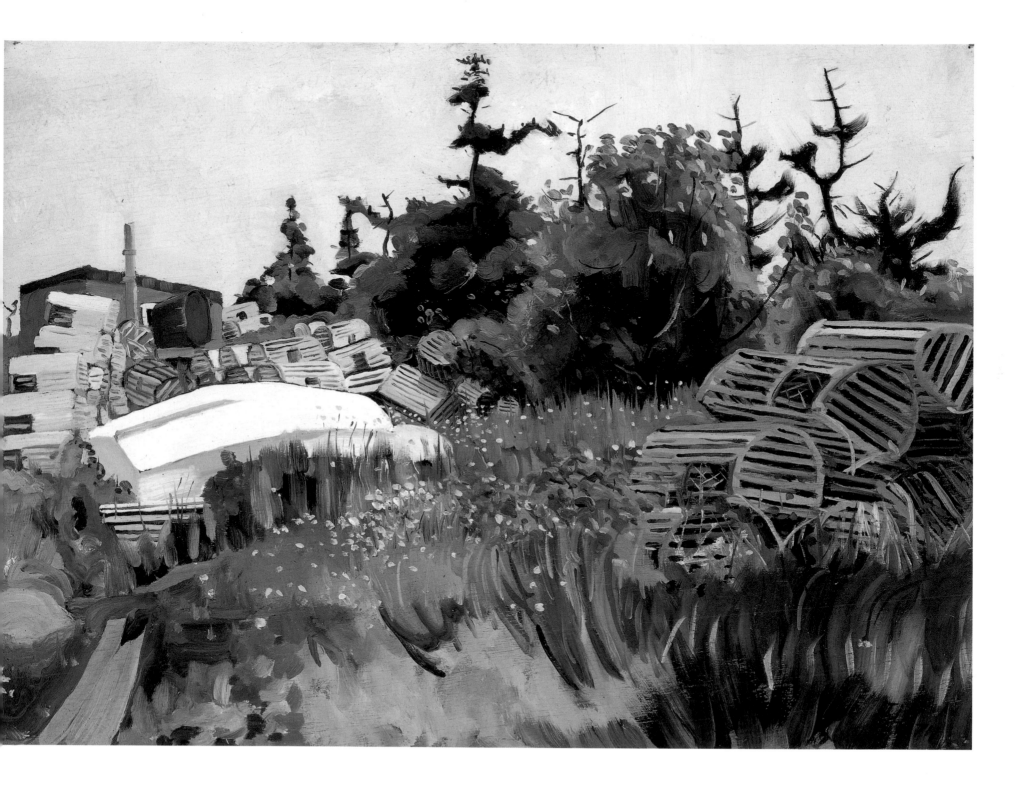

RANDALL DAVEY
A BLOW AT MONHEGAN, C. 1915
OIL ON BOARD, 18 X 22 IN.
COURTESY FARNSWORTH ART MUSEUM, MUSEUM PURCHASE

CHRISTOPHER HUNTINGTON
SUMMER AND WINTER, HARBOR POINT, MATINICUS, 1974
OIL ON BOARD, 16 X 22 IN.
COURTESY BAYVIEW GALLERY, PORTLAND

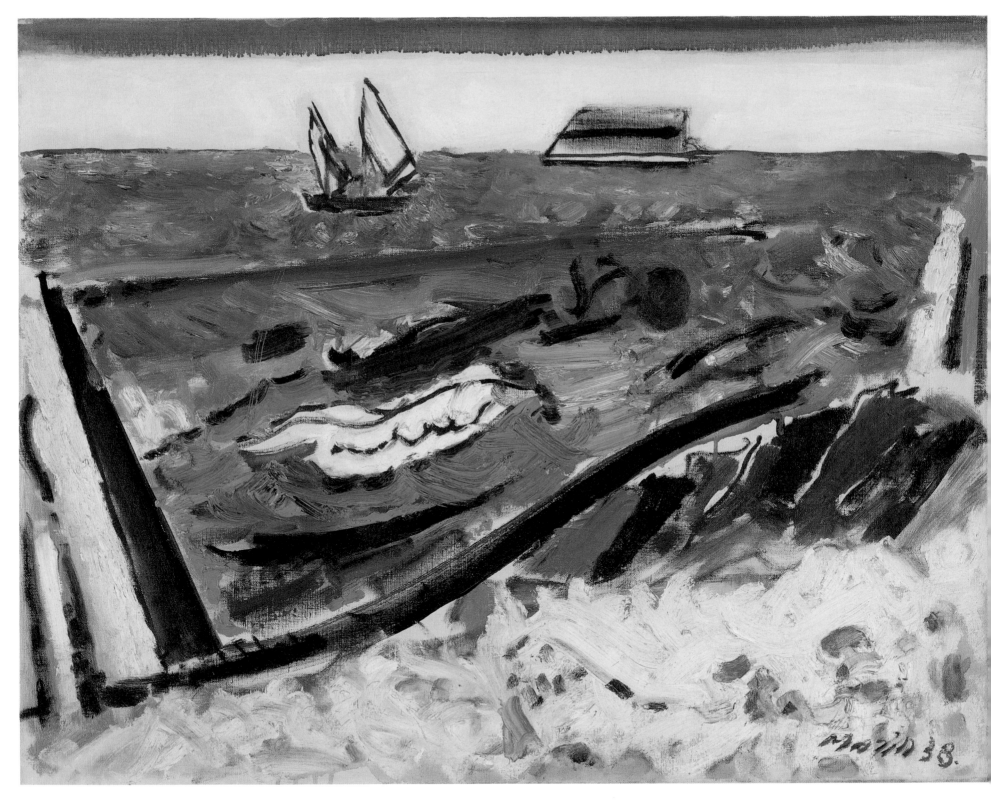

JOHN MARIN, *OFF CAPE SPLIT, MAINE,* 1938, OIL ON CANVAS, 22 1/8 X 28 1/8 IN.

COURTESY METROPOLITAN MUSEUM OF ART, GEORGE A. HEARN FUND, 1946, PHOTOGRAPH © 1985 THE METROPOLITAN MUSEUM OF ART

Grace for an Island Meal

Bless this board and bless this bread.
Bless this skylight over head
Through which any eye may see
Wheeling gull and blowing tree.
Bless this cloth of woven blue.
Bless these chanterelles that grew
In secret under mossy bough.
Bless the Island pastured cow
For her milk which now we pour.
Bless these berries from the shore.
Bless every fresh laid egg and then
Blessing on each Island hen.
Bless the sweet smelling bowl of bay;
This tea from islands far away.
Bless spoon, and plate, and china cup,
The places set for us to sup
In sight of sky, in sound of sea—
Bless old and young, bless You and Me.

—Rachel Field, from *The Pointed People*, 1940

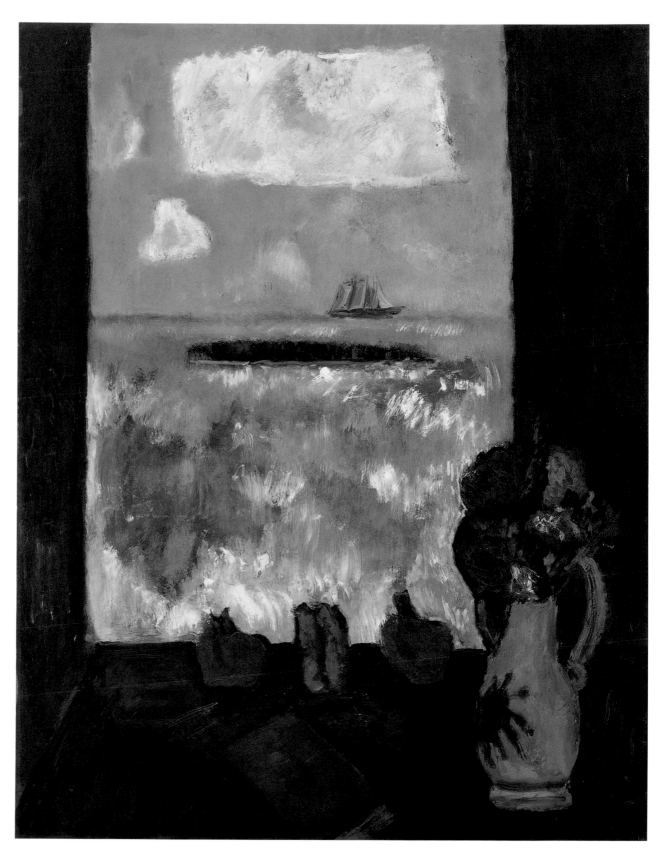

MARSDEN HARTLEY
SUMMER SEA, WINDOW, RED CURTAIN, 1942
OIL ON MASONITE, 40 x 30 IN.
COURTESY ADDISON GALLERY OF AMERICAN ART
PHILLIPS ACADEMY, ANDOVER, MASSACHUSETTS
PHOTO BY GREG HINES

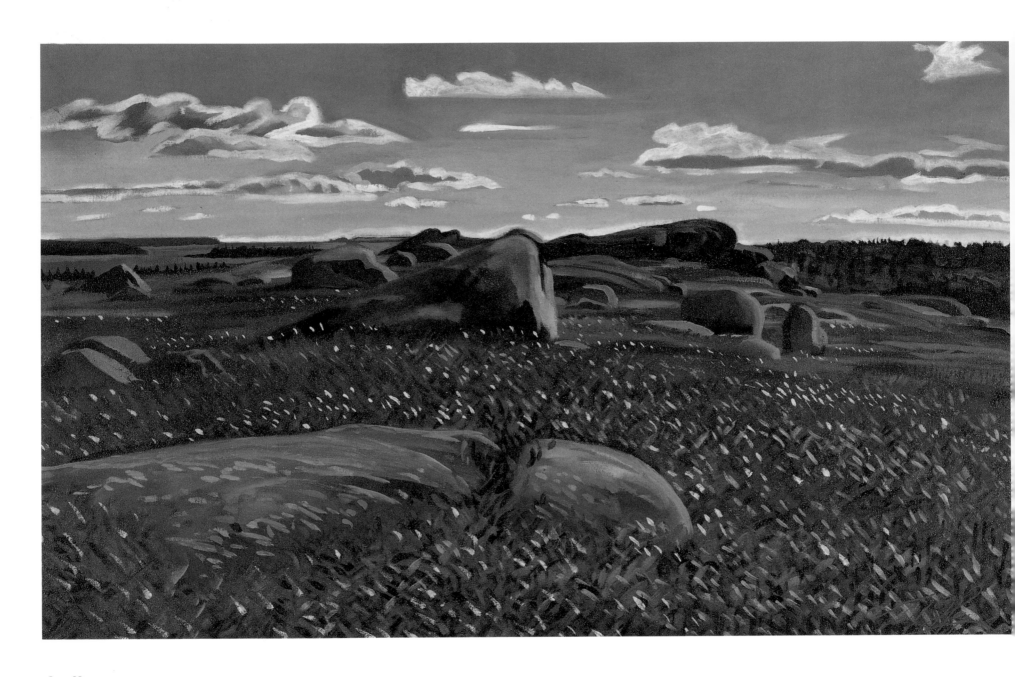

Jill Hoy
The Barrens, Ridge Road, 1993
Oil on canvas, 24 x 36 in.
Courtesy Chase Gallery, Boston
Photography by Darwin davidson

Sara Weeks Peabody
Blueberry Barrens in October, 1992
Watercolor on paper, 22 x 29 in.
Collection of Francis Weld Peabody

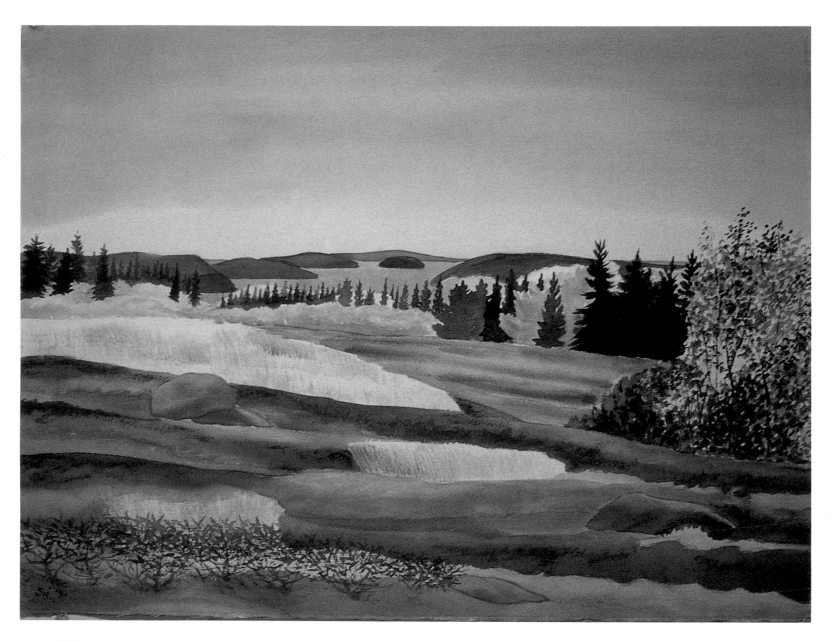

But supposing yourself almost anywhere in Maine, within fifteen miles of the shore, and you start for a ride to the sea side.... The sea, living, beautiful and life-giving, seems, as you ride, to be everywhere about you—behind, before, around. Now it rises like a lake, gemmed with islands, and embosomed by rich swells of woodland. Now, you catch a peep of it on your right hand, among tufts of oak and maple, and anon it spreads on your left to a majestic sheet of silver, among rocky shores, hung with dark pines, hemlocks, and spruces.

—Harriet Beecher Stowe, "Letter from Maine," 1852

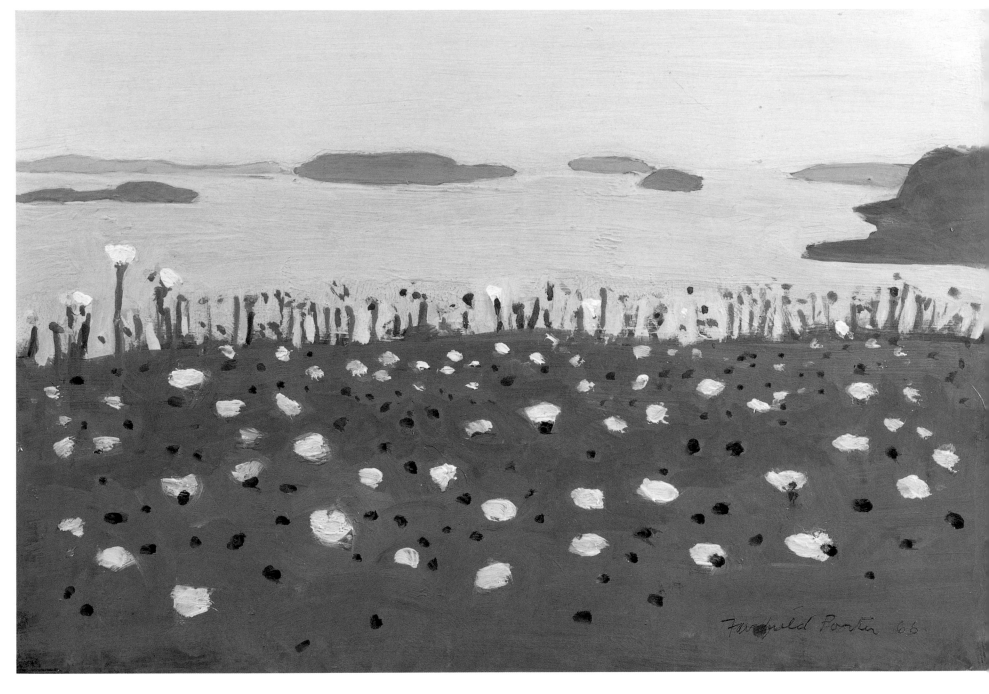

FAIRFIELD PORTER, *QUEEN ANNE'S LACE*, 1966, OIL ON MASONITE, 19 3/4 X 15 IN.
COURTESY LOCKS GALLERY, PHILADELPHIA

FRANK METZ, *PRETTY MARSH*, 1992, OIL ON CANVAS, 48 X 48 IN.
COURTESY FROST GULLY GALLERY

In all of my conversations with Maine artists I was aware of a *simpatico* that exists, as it does nowhere else I know of in America, between the artist and his chosen sanctuary of inspiration.
—Martin Dibner, *Seacoast Maine: People and Places*, 1973

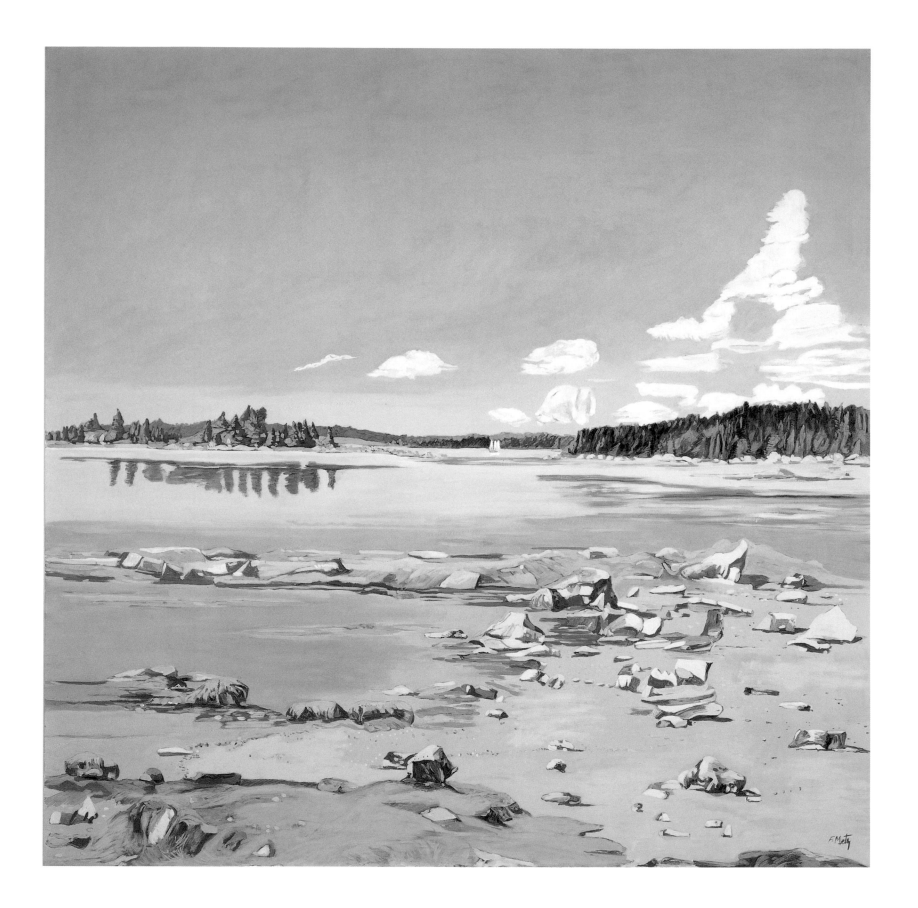

51

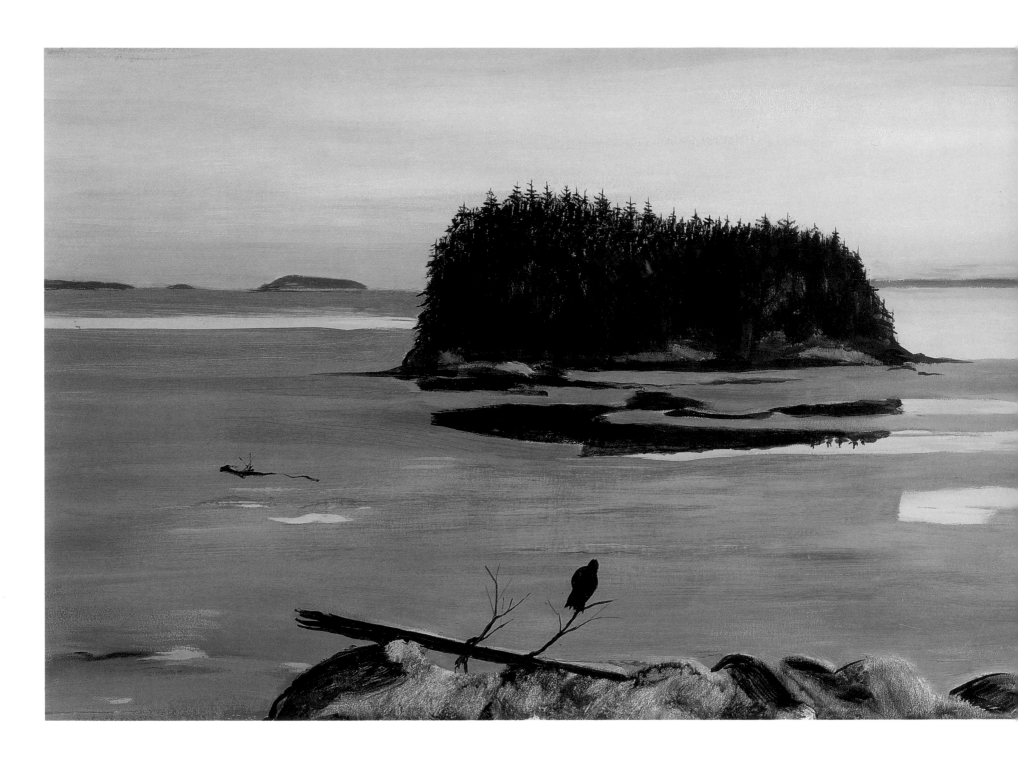

STEPHEN ETNIER, *ICE FLOES*, 1974, OIL ON CANVAS, 16 X 36 IN., COLLECTION OF FLEET BANK OF MAINE, COURTESY FROST GULLY GALLERY

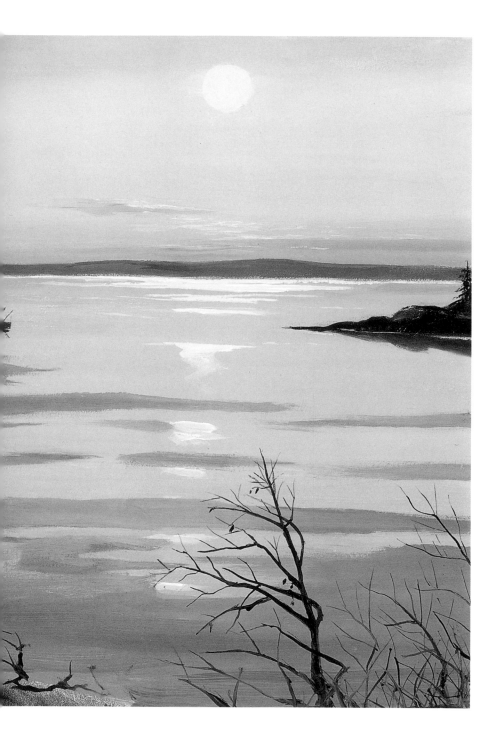

It had been growing gray and cloudy, like the first evening of autumn, and a shadow had fallen on the darkening shore. Suddenly, as we looked, a gleam of golden sunshine struck the outer islands, and one of them shone out clear in the light, and revealed itself in a compelling way to our eyes. Mrs. Todd was looking off across the bay with a face full of affection and interest. The sunburst upon that outermost island made it seem like a sudden revelation of the world beyond this which some believe to be so near.

—Sarah Orne Jewett, *The Country of the Pointed Firs,* 1896

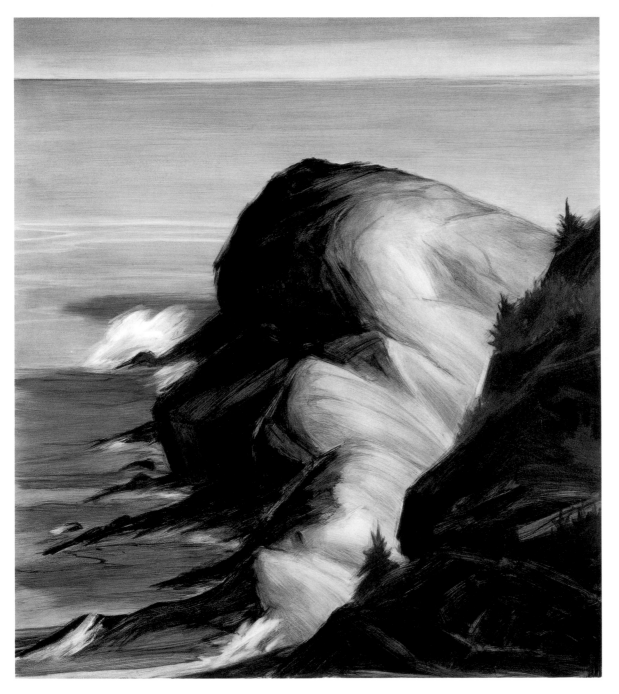

The Rowers

Always we were aware of the islands, the interminable sea
Against our ears, drawn by the tides seaward;
Yet we remained in those estuaries, those island waters,
While the seasons drifted. Leeward.

Vast tides climbed savagely between crags;
Leeward, gulls flew in perpetual, unending arcs of white.
It was a landscape where birds moved in joy,
Their movements praise for undying light.

And we, rowers between crags, the gigantic cliffs,
Moved to a tide change, the endless rhythm
Of the mighty waters, held in the hand of God,
Transfixed in a vast and an eternal prism.

Always we were aware of the islands, glad of time
Whose sandals were slow, glad of day without motion.
We have left upon the sand the signature of our love;
You will find it there by the soft and blue-tongued ocean.

—Harold Vinal

MARGUERITE ROBICHAUX, *GULL ROCK*, 1990
OIL ON PAPER, 51 X 46 IN.
COURTESY O'FARRELL GALLERY, BRUNSWICK, MAINE

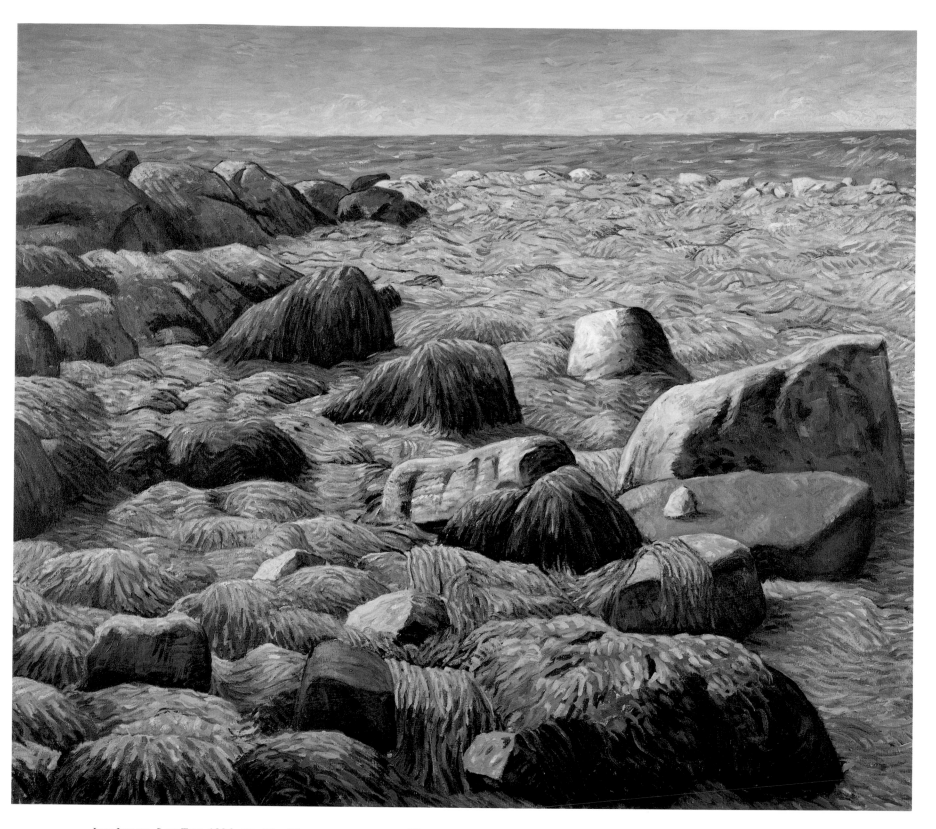

JON IMBER, *LOW TIDE*, 1986, OIL, 70 X 80 IN., COLLECTION OF METROPOLITAN LIFE INSURANCE CO., NEW YORK, PHOTOGRAPHY BY ADAM REICH

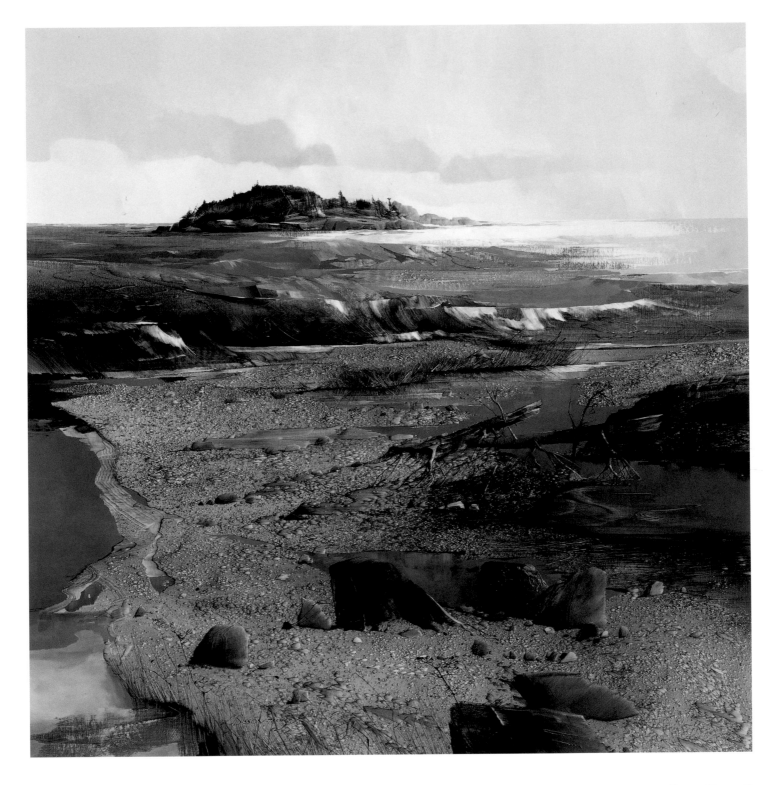

LAURENCE SISSON, *PUMPKIN ISLAND*, 1975, OIL ON PANEL, 44 X 44 IN., COLLECTION OF GORDON AND SALLY WOODWORTH, COURTESY FROST GULLY GALLERY

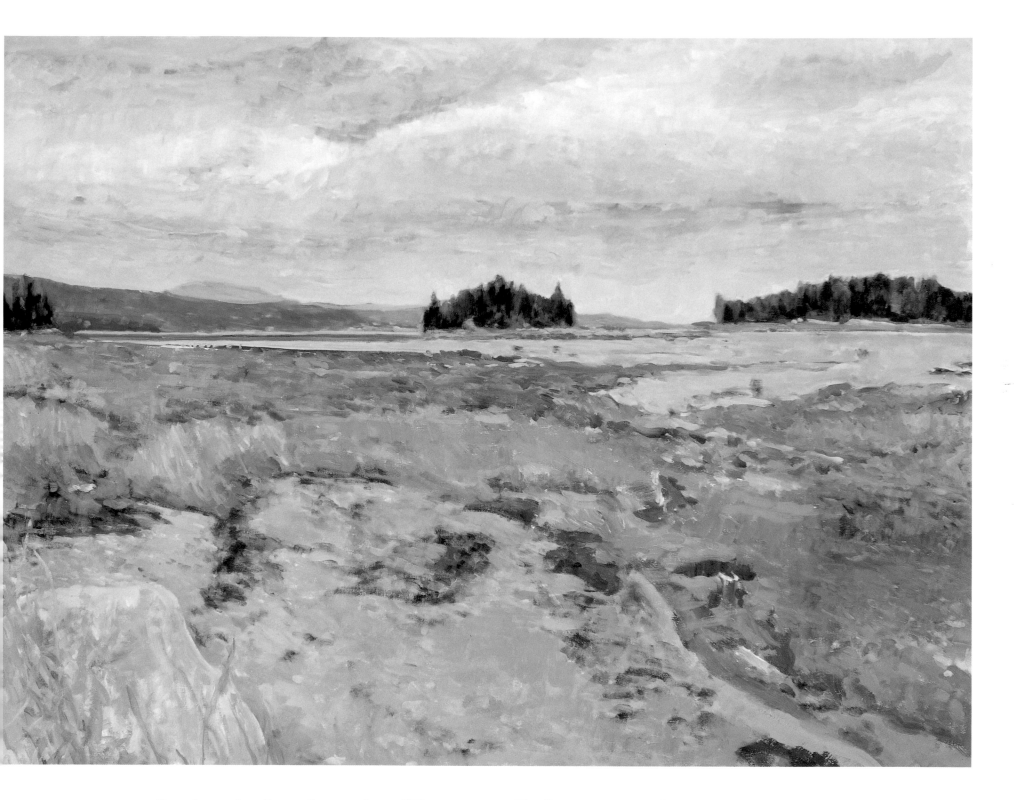

DAVID LITTLE, *LONG POINT — CRANBERRY ISLAND*, 1989, OIL ON CANVAS, 36 X 48 IN., COLLECTION OF MR. AND MRS. JOHN JENKINS

When I stood at the top of the hill to look around, it seemed as though there were an extra glory in everything just to welcome me. Stephen said it was the most beautiful day of the year. The blue sky, the river deep sapphire with an ever-moving ribbon of pure white foam running over it, some white breakers on the spit of beach, and the islands set like dark accents among the sparkling diamonds and sapphires that were the sea. The horizon was a clean dark line, and the sky paled down to it....

—Elizabeth Etnier, *On Gilbert Head: Maine Days*, 1937

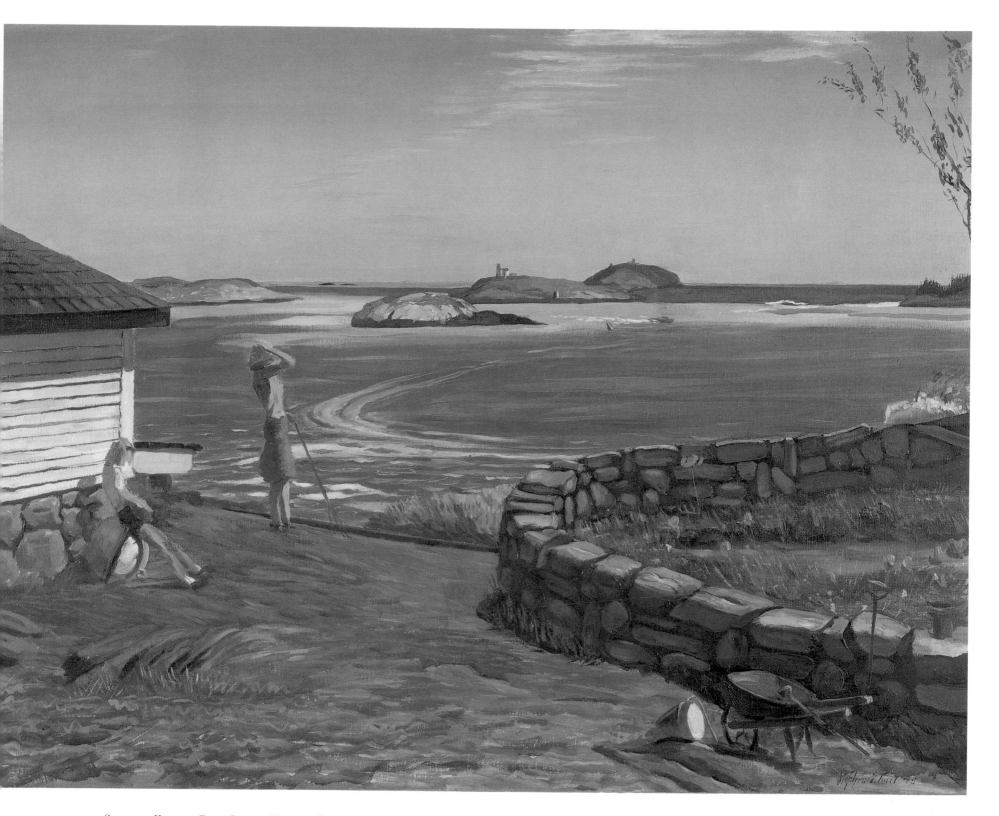

Stephen Etnier, *From Gilbert Head*, 1945, oil on canvas, 28 x 35 7/8 in., collection of Martin Memorial Library, York, Pennsylvania

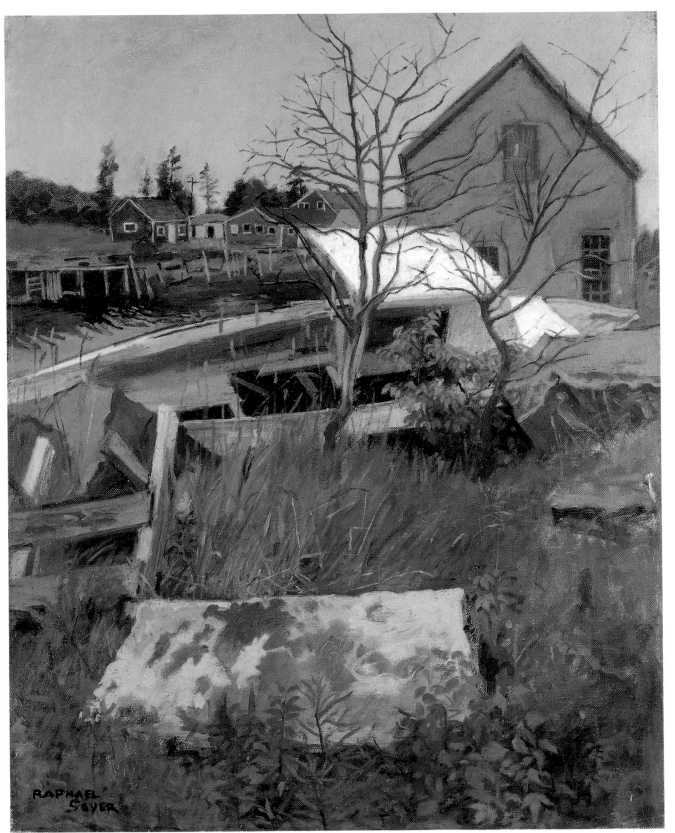

60

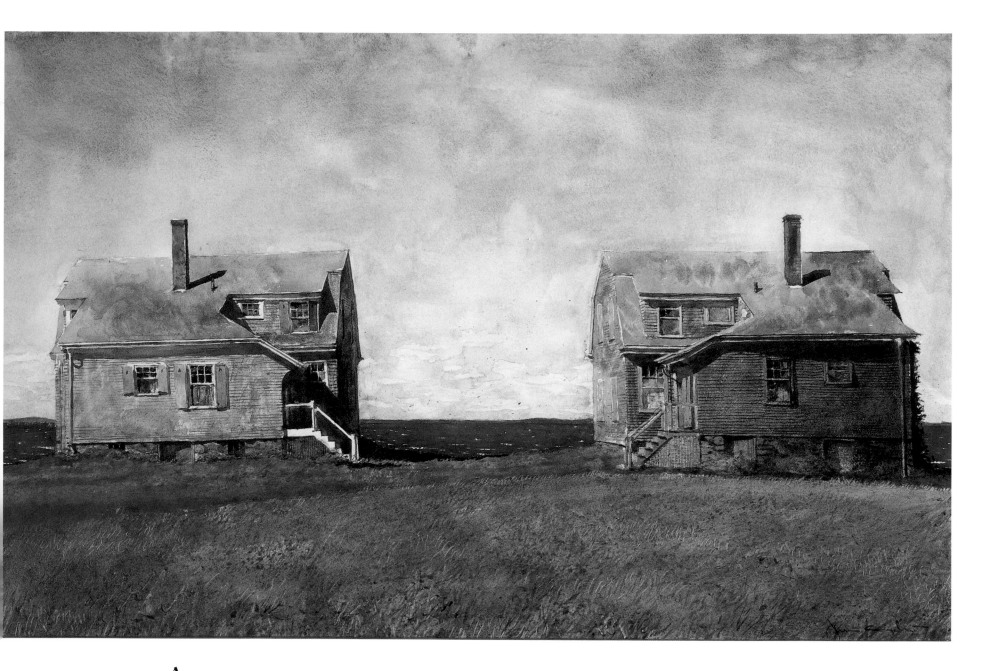

All of my childhood I wanted to live aboard a boat—always an exciting idea. But, you know, when you're on a boat three weeks, it gets pretty crampy. This island [Monhegan] is perfect for me. This house is like a boat but you also have the land.

...To me, an island is a microcosm of a continent. I look at things growing around here as if they weren't carried, but simply formed here from whatever grew.

—Jamie Wyeth, cited in Martin Dibner's *Seacoast Maine*, 1973

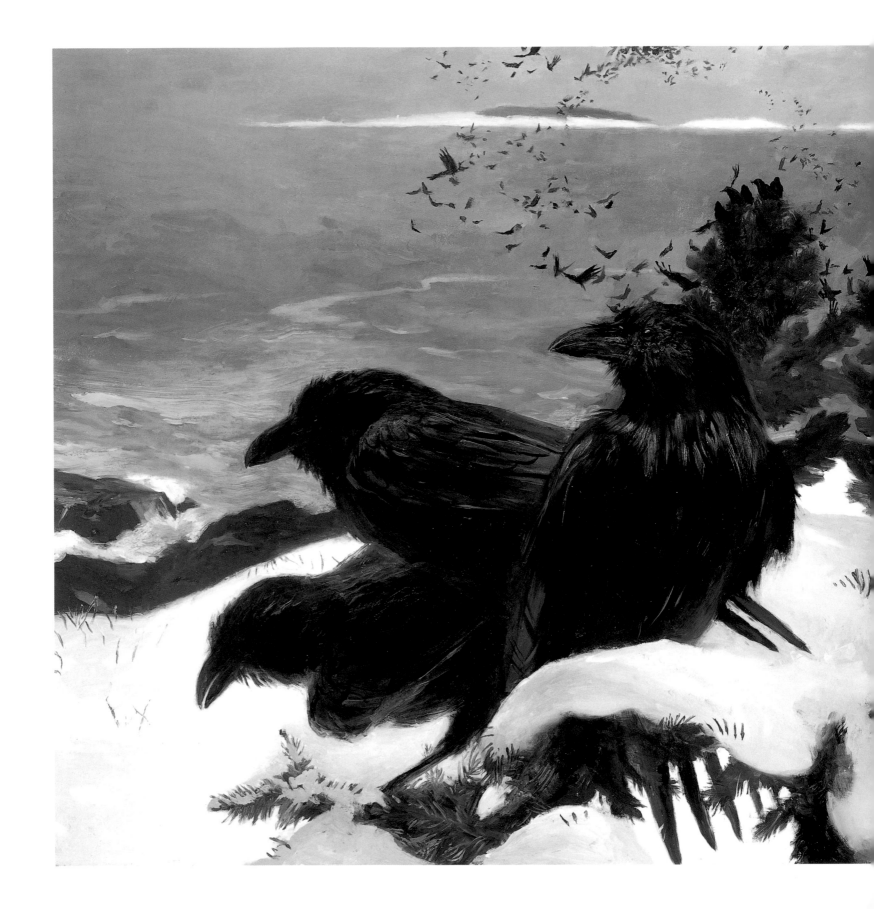

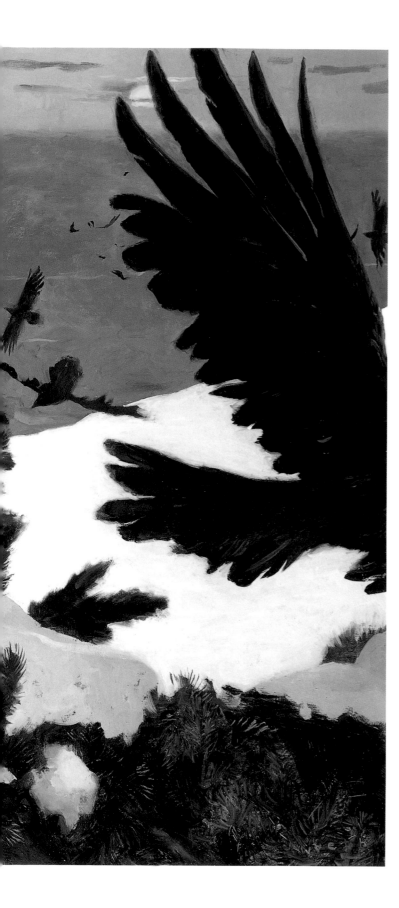

Ravens on Great Cranberry

Their cries are like the raucous calls
of devilish boys imitating Indians
as they creep through the island woods.

They can deliver a disturbing commentary
on even the smallest failure, like the cruel applause
that follows a dropped dish in a crowded cafeteria.

The opposite of good children—heard
and not seen--at dusk a gang of them
disrupts a croquet game with their off-key chorus.

One day some scientist will prove
their virtual necessity in the chain
of Maine island life. For now, however,

the ravens come forth over alder tops,
wingtips splayed by unseen breezes, fresh
obscenities forming in their jet-black throats.

—Carl Little

JAMIE WYETH, *RAVENS IN WINTER*, 1996, OIL ON BOARD, 30 x 48 IN., © JAMIE WYETH *63*

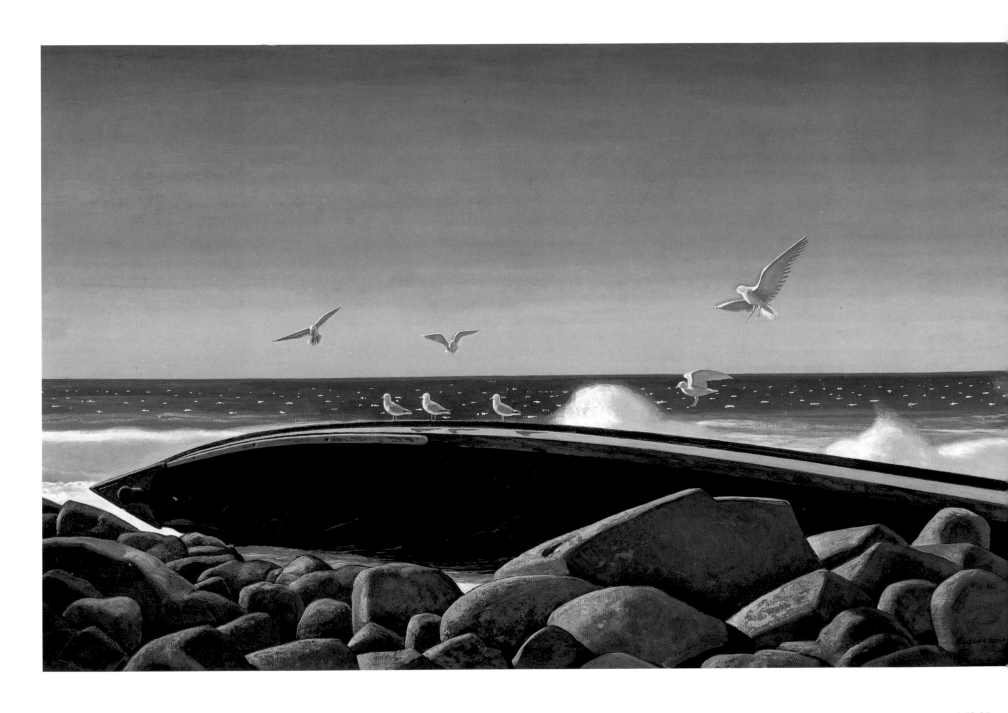

ROCKWELL KENT, *WRECK OF THE D. T. SHERIDAN*, C. 1948–1953, OIL ON CANVAS, 27 3/4 X 43 3/4 IN., PORTLAND MUSEUM OF ART, MAINE, BEQUEST OF ELIZABETH B. NOYCE; 1996.38.25

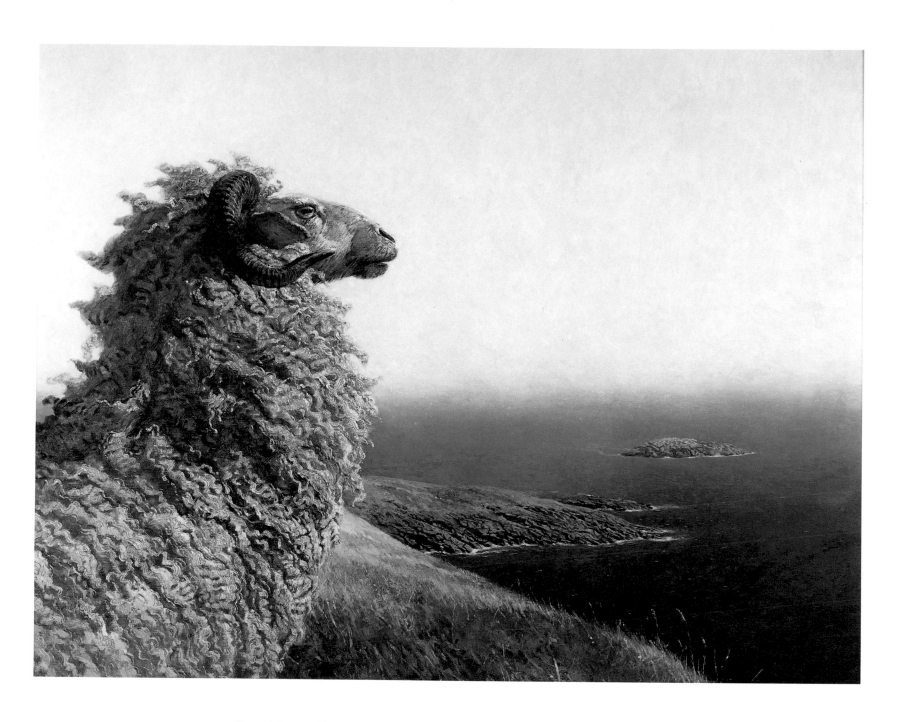

JAMIE WYETH, *THE ISLANDER*, 1975, OIL ON CANVAS, 34 X 44 IN., © JAMIE WYETH

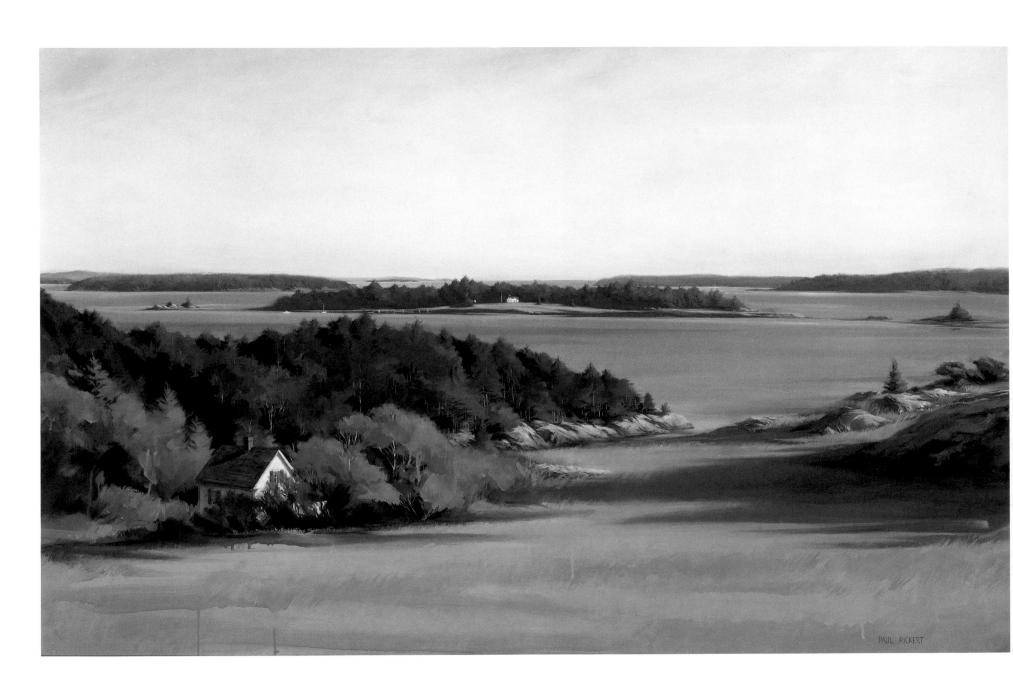

PAUL RICKERT, *THE ISLANDS*, 1974, OIL ON CANVAS, 30 X 48 IN., COLLECTION OF KEY BANK OF MAINE, COURTESY FROST GULLY GALLERY

...This is peace, the indifference of nature, another year
Seeming the same as the year before,
The static ability of the world to endure.
There is Eagle Island twelve miles down the bay,
A mole has just dared to march over our garden,
The far islands seem changeless through decades.

—Richard Eberhart, "Coast of Maine"

THOMAS CROTTY, *SUNRISE—DEER ISLE*, 1993, OIL ON CANVAS, 8 x 12 IN., PRIVATE COLLECTION, COURTESY FROST GULLY GALLERY

MICHAEL H. LEWIS, *Konrad Oberhuber's Visit to Compass Harbor, Maine*, 1985, OIL ON CANVAS, 30 X 30 IN.
COLLECTION OF DR. KONRAD OBERHUBER, DIRECTOR, ALBERTINA MUSEUM, VIENNA, AUSTRIA

"A kind of constellation when the light
Is rare enough, and you can see as far
Down east as this," you say, "the islands are,
Of several magnitudes, though none so bright
As Deneb or Arcturus on a night
Moonless and black, without a cloud to mar
Its depth, so clear the least imposing star
In Cygnus or Boötes shines out white.
Ironbound, Jordan, Yellow, Heron, Stave,
Calf, Preble, Dram…" You link them one by one
Into the figure of a giant brave
Asleep in Frenchman Bay, though you must know
The islands need the great daystar, the sun,
To be made out even in fancy so.

—Samuel French Morse,
 from "The Islands in Summer"

BRITA HOLMQUIST, *LATE SUN*, 1989
OIL ON LINEN, 56 x 41 1/2 IN.
COLLECTION OF WILLIAM KNOWLES, PORTLAND, MAINE

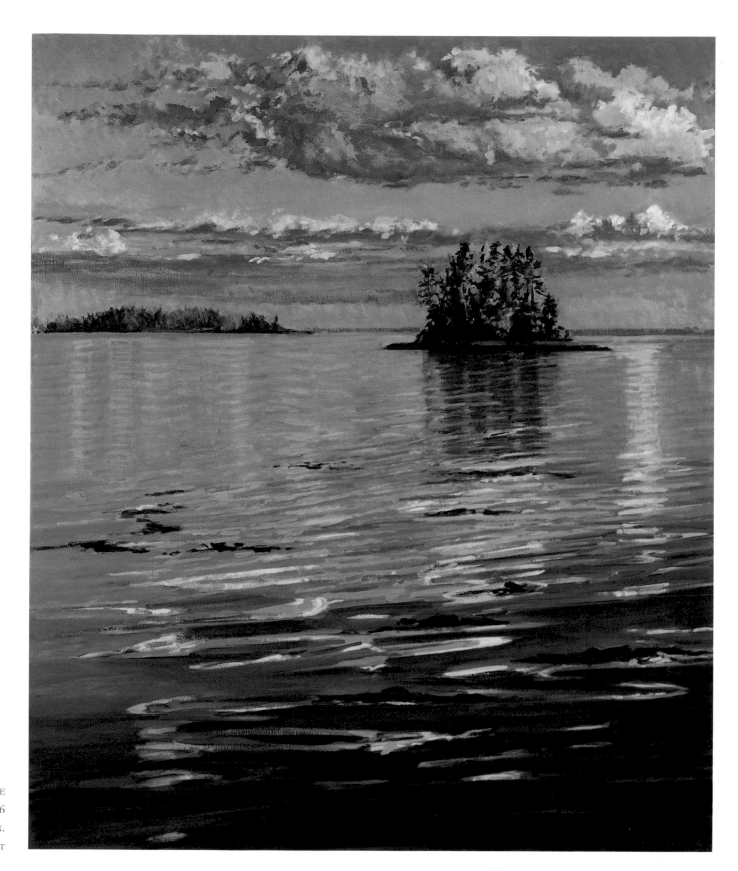

NINA JEROME
EARTH, AIR, WATER, AND LIGHT, 1996
OIL ON CANVAS, 40 X 36 IN.
COLLECTION OF THE ARTIST

It has been a summer of bad weather and really cold, but I so love it up here [on Mt. Desert Island] that rain and fog are nicer here than good weather elsewhere, and today the fog has cleared and I see a blue ocean which sparkles—what Aeschylus calls 'The never numbered laughter of sea waves.' They do seem to be laughing.

—Edith Hamilton, letter to family, 1960

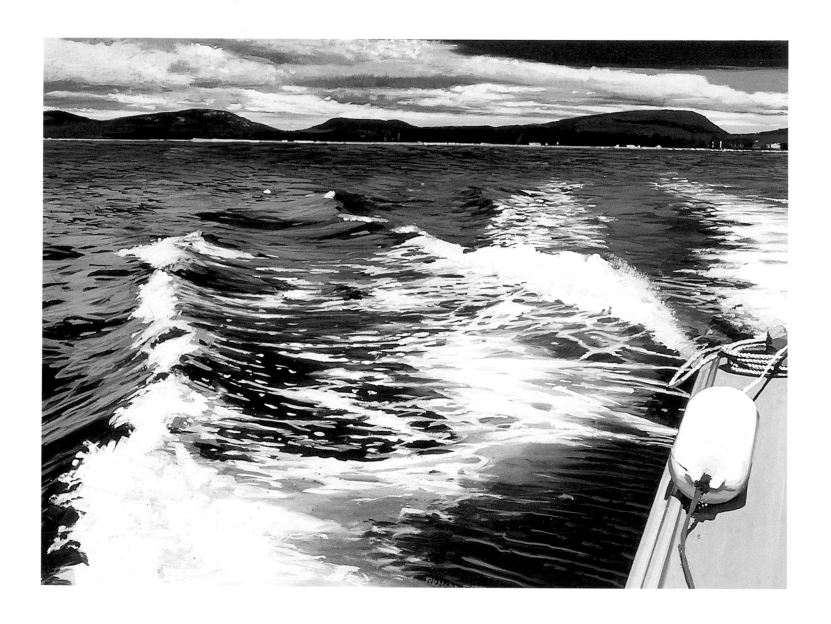

RICHARD ESTES, *MOUNT DESERT VI*, 1996, OIL ON WOOD, 14 1/2 X 20 1/4 IN., © RICHARD ESTES, 1997, COURTESY MARLBOROUGH GALLERY

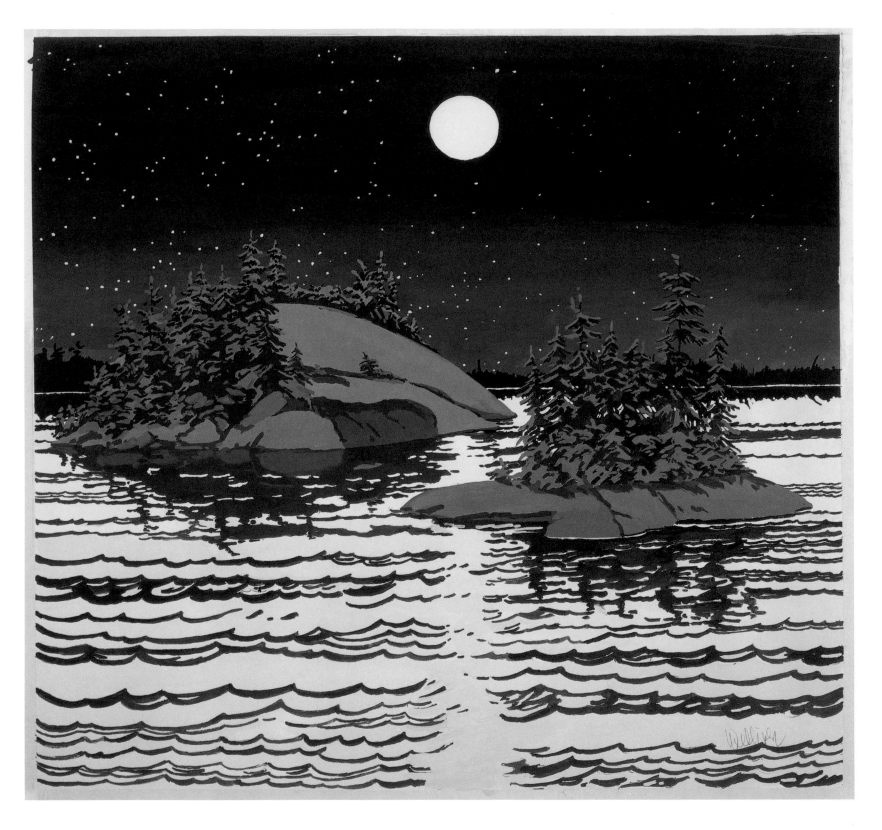

Neil Welliver, *Islands, Allagash*, 1989, Gouache on paper, 28 x 29 3/8 in., courtesy Marlborough Gallery

Karl Schrag, *Island Night*, 1978, oil on canvas, 48 1/2 x 54 1/8 in., Courtesy Farnsworth Art Museum, Gift of Paul J. Schrag, Photography by Melville D. McLean

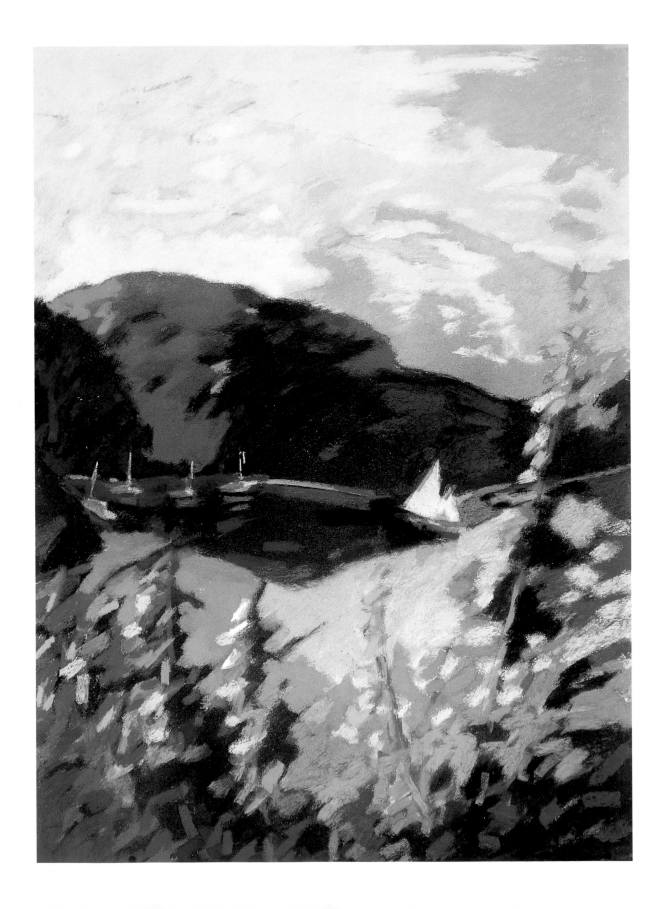

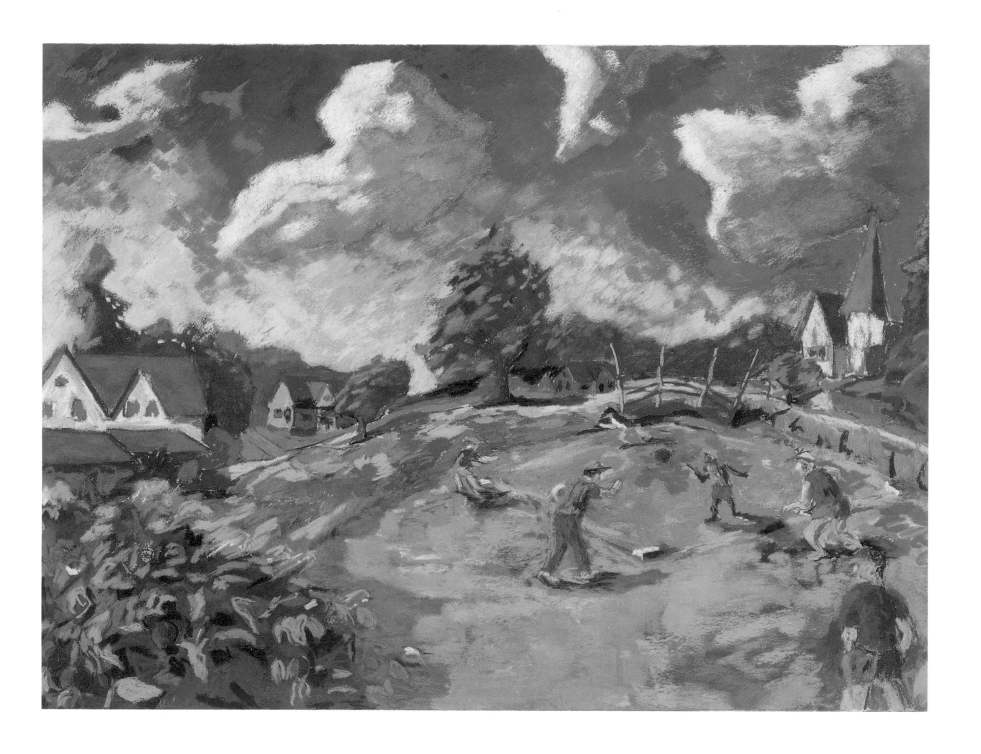

HENRY ISAACS

SOMES SOUND FROM SCHOOL HOUSE LEDGE, 1988

PASTEL ON PAPER, 30 x 22 IN.

COLLECTION OF CHRISTOPHER DAVIS, NEW YORK

DAN FERNALD

MALCOLM'S BIRTHDAY — TOWN FIELD, ISLESFORD, 1994

PASTEL, 22 x 30 IN.

COLLECTION OF MALCOLM FERNALD

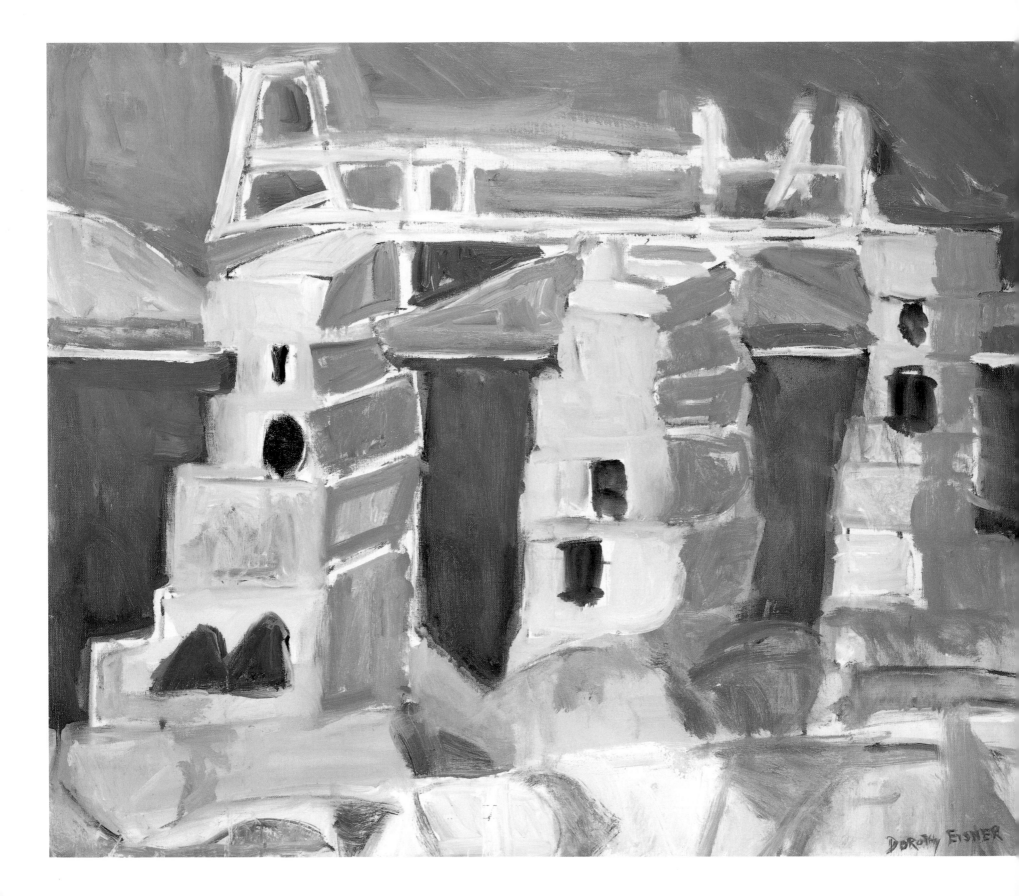

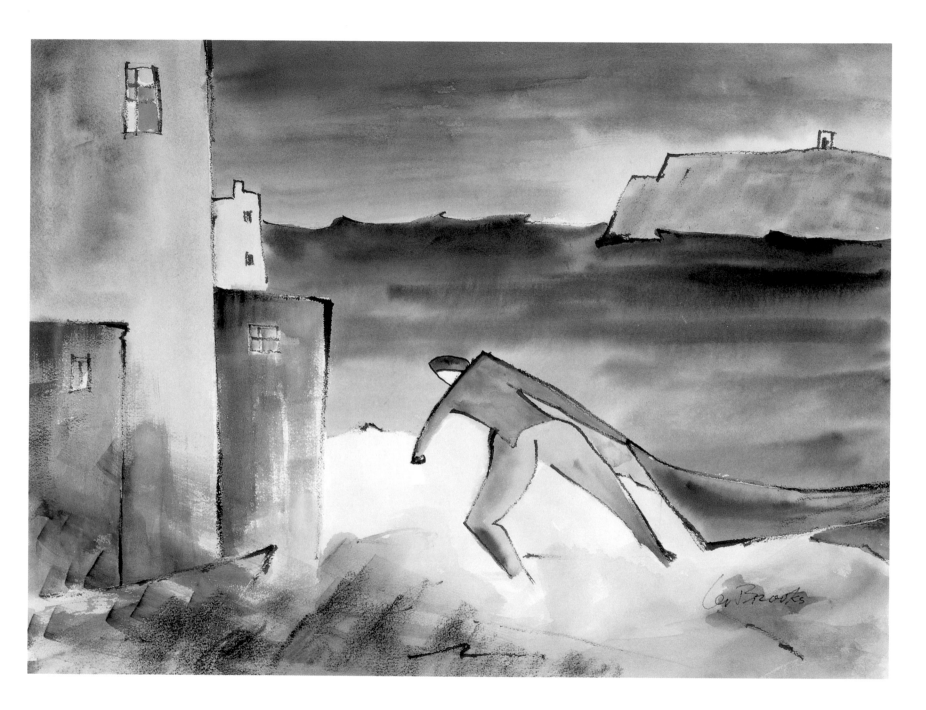

DOROTHY EISNER
STONE DOCK II, 1981
OIL ON CANVAS, 25 x 30 IN.
COLLECTION OF CHRISTIE MCDONALD

LEO BROOKS
MAN HAULING UP THE BOAT, N.D.
WATERCOLOR, 29 1/2 x 21 1/2 IN.
COLLECTION OF PETER AND BETSEY RALSTON

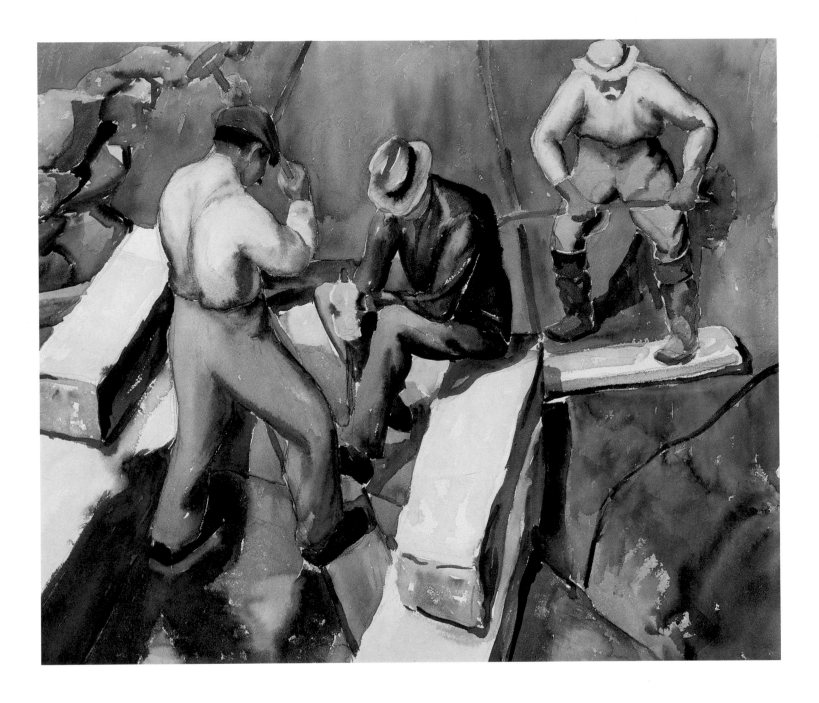

WILLIAM H. MUIR

THE QUARRIERS, C. 1940

WATERCOLOR, 20 X 22 IN.

COLLECTION OF JOHN AND A.M. GOLDKRAND

COURTESY GLEASON FINE ART

JOELLYN DUESBERRY

ABOVE THE GRANITE QUARRY, 1996

OIL ON LINEN, 66 X 42 IN.

COURTESY JAMES GRAHAM & SONS, INC., NEW YORK

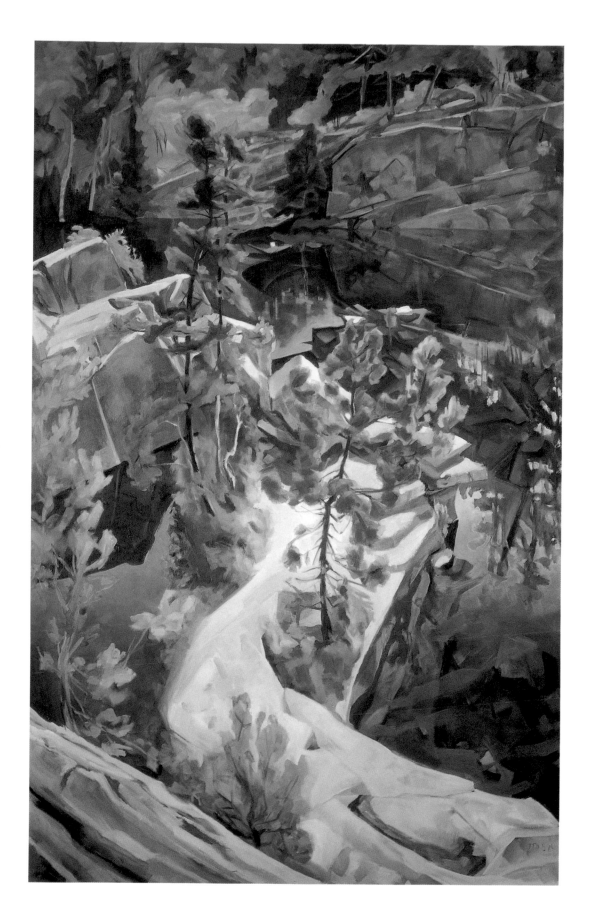

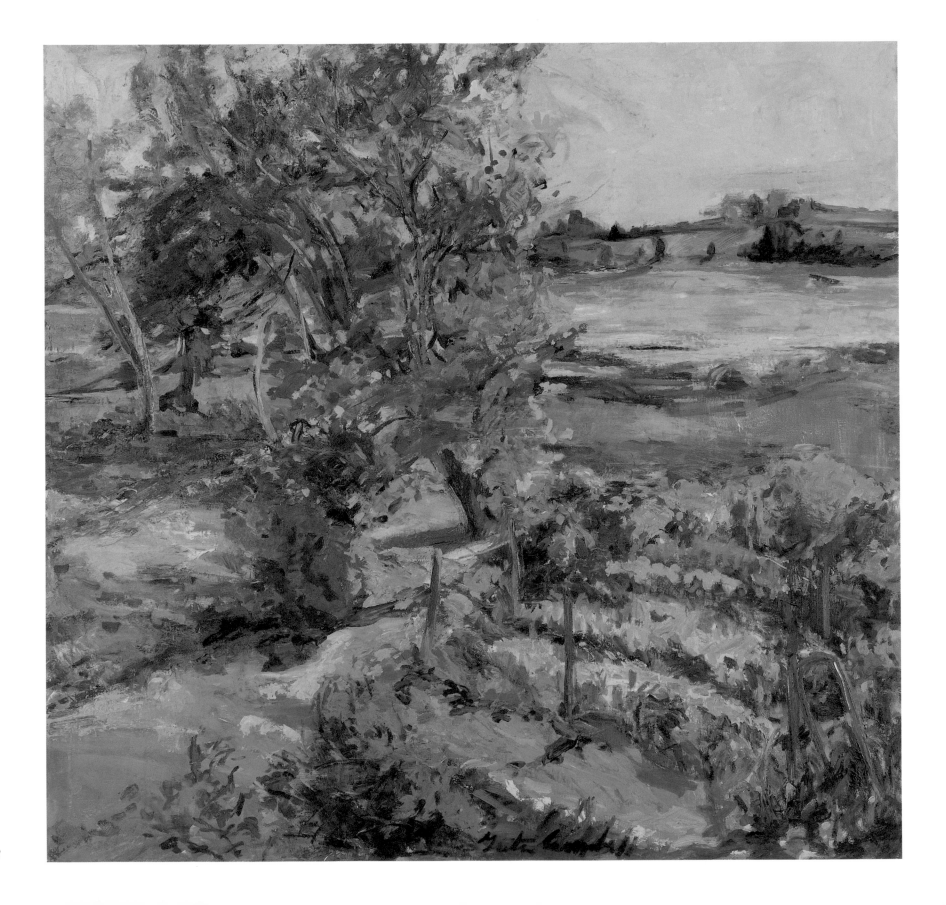

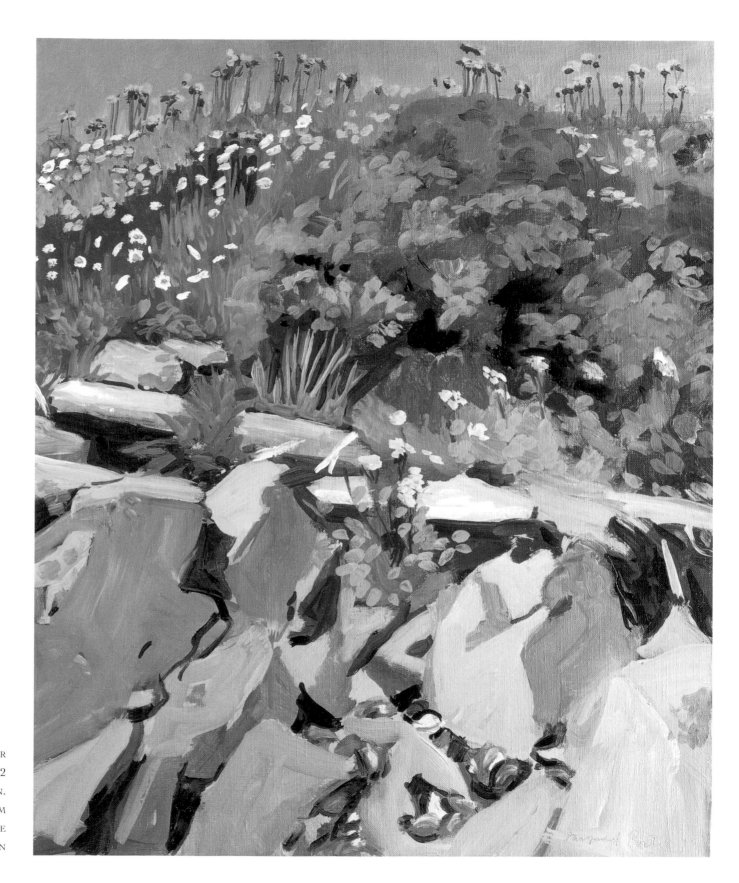

GRETNA CAMPBELL, *PLUM TREE*, 1985
OIL ON CANVAS, 44 X 46 IN.
COURTESY TIBOR DE NAGY GALLERY
NEW YORK

FAIRFIELD PORTER
BEACH FLOWERS NO. 2, 1972
OIL ON CANVAS, 24 1/4 X 20 1/8 IN.
COURTESY FARNSWORTH ART MUSEUM
ESTATE OF MRS. ELIZABETH B. NOYCE
PHOTOGRAPHY BY MELVILLE D. MCLEAN

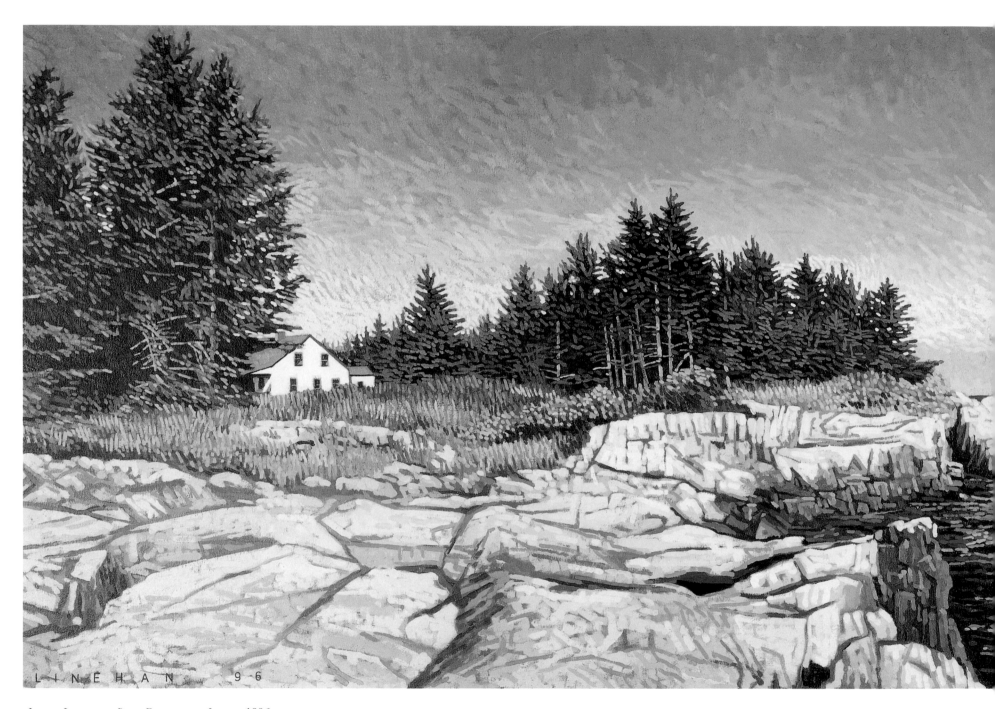

JAMES LINEHAN, *BOTH ENDS OF THE ISLAND*, 1996

OIL ON CANVAS, 30 x 60 IN.

COURTESY SHERRY FRENCH GALLERY, NEW YORK

© JAMES LINEHAN, 1996

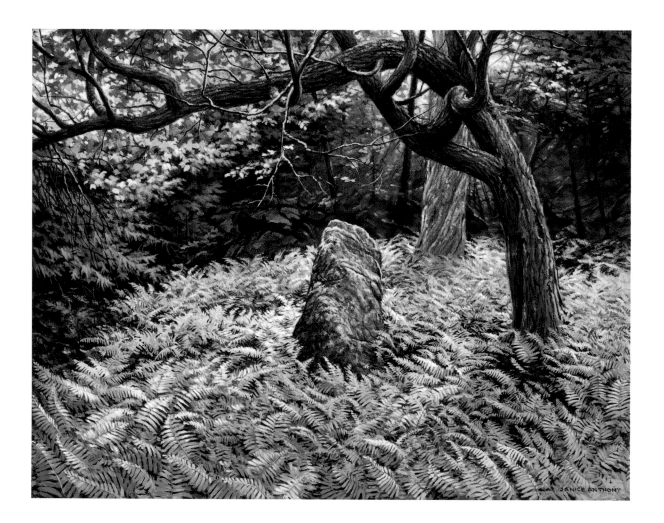

JANICE ANTHONY
STANDING STONE, ISLE AU HAUT, 1996
ACRYLIC ON LINEN, 14 x 18 IN.
COURTESY FROST GULLY GALLERY

Here in Maine, still within our arms' reach in the late 20th century, we find a multitude of these once lightly inhabited islands, places that are rich in the ways of maritime history and culture. Places that, the smaller and more enclosed they are, the larger the window on the infinite, the farther they telescope to the heavens.

These are spirited and peopled places, and we must consider carefully how to keep these worlds balanced between accessibility and inaccessibility, because in one single moment of solitude, they provide our callous name-collecting natures something as precious as vision itself.

—Philip W. Conkling, "Solitude" (on Flint Island)

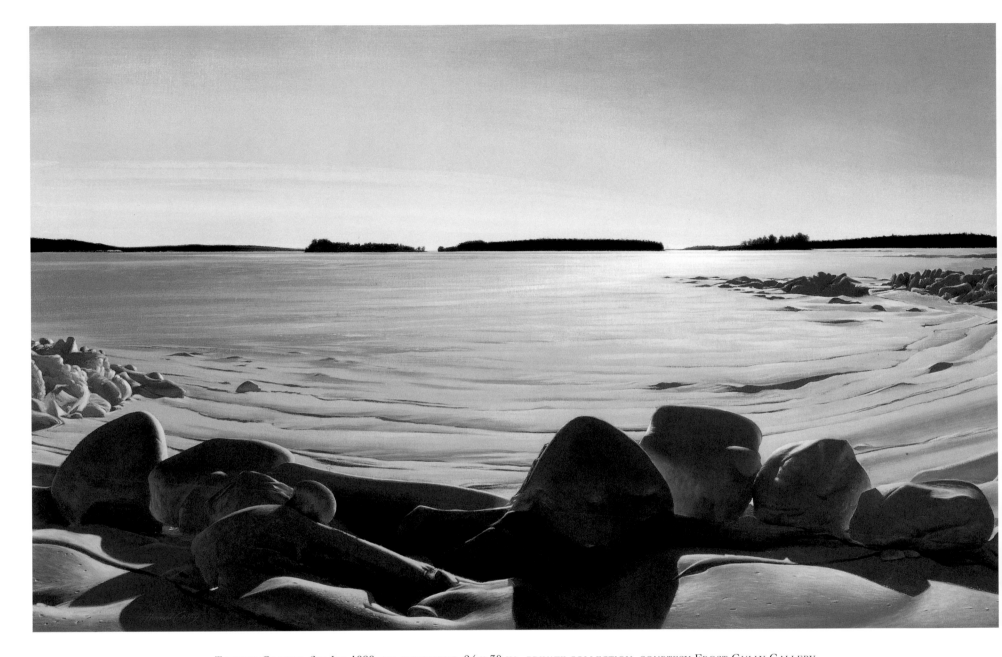

THOMAS CROTTY, *SEA ICE*, 1989, OIL ON CANVAS, 24 X 30 IN., PRIVATE COLLECTION, COURTESY FROST GULLY GALLERY

The Islanders

Winters when we set our traps offshore,
we saw an island further out than ours,
miraged in midday haze, but lifting clear
at dawn, or late flat light, in cliffs that might
have been sheer ice. It seemed, then, so near,

that each man, turning home with his slim catch,
made promises beyond the limits of his gear
and boat. But mornings we cast off to watch
the memory blur as we attempted it,
and set and hauled on ledges we could fetch

and still come home. Summers, when we washed
inshore again, not one of us would say
the island's name, though none at anchor sloshed
the gurry from his deck without one eye
on that magnetic course the ospreys fished.

Winters, then, we knew which way to steer
beyond marked charts, and saw the island, as
first islanders first saw it: who watched it blur
at noon, yet harbored knowing it was real;
and fished, like us, offshore, as if it were.

—Philip Booth

THOMAS PAQUETTE, *GREAT WASS, WINTER IV*, 1993, OIL ON CANVAS, 32 x 40 IN., COLLECTION OF THE ARTIST

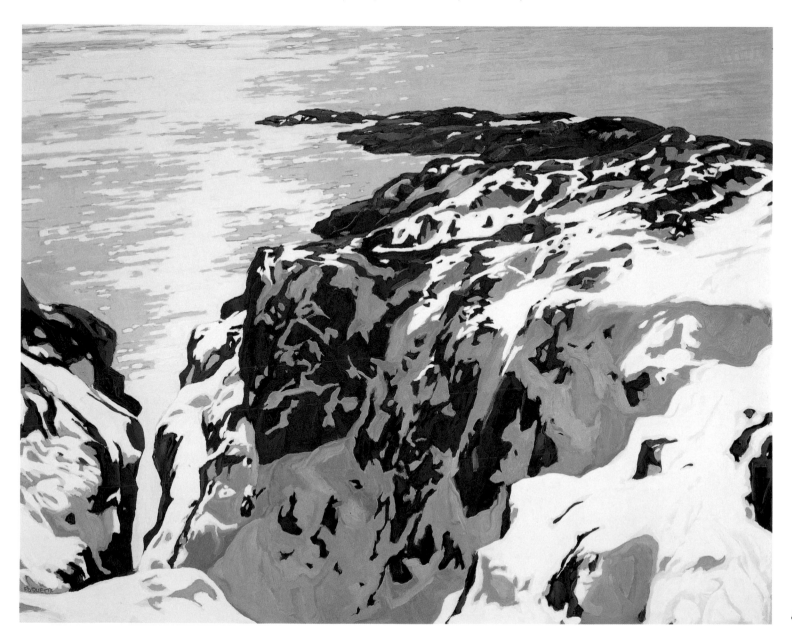

Mirage

The wind was in another country, and
the day had gathered to its heart of noon
the sum of silence, heat, and stricken time.
Not a ripple spread. The sea mirrored
perfectly all the nothing in the sky.
We had to walk about to keep our eyes
from seeing nothing, and our hearts from stopping
at nothing. Then most suddenly we saw
horizon on horizon lifting up
out of the sea's edge a shining mountain
sun-yellow and sea-green; against it surf
flung spray and spume into the miles of sky.
Somebody said mirage, and it was gone,
but there I have been living ever since.

—R.P. Blackmur, Part IX of "Sea Island Miscellany"

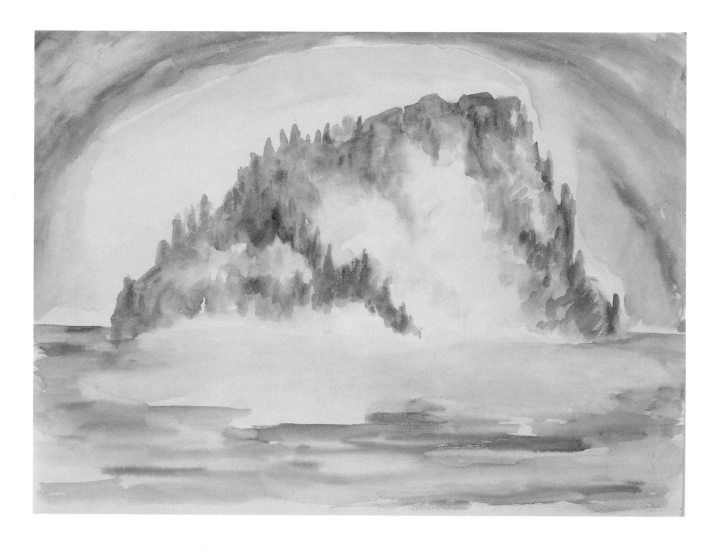

ELEANOR LEVIN, *BALD PORCUPINE*, 1989, WATERCOLOR ON ARCHES, 22 x 30 IN., COLLECTION OF THE ARTIST

NICHOLAS SNOW, *HAY ISLAND*, 1986, ACRYLIC ON MASONITE, 24 x 52 IN., COLLECTION OF COLIN BAKER AND ELAINE CINCIVA, CASTINE, MAINE

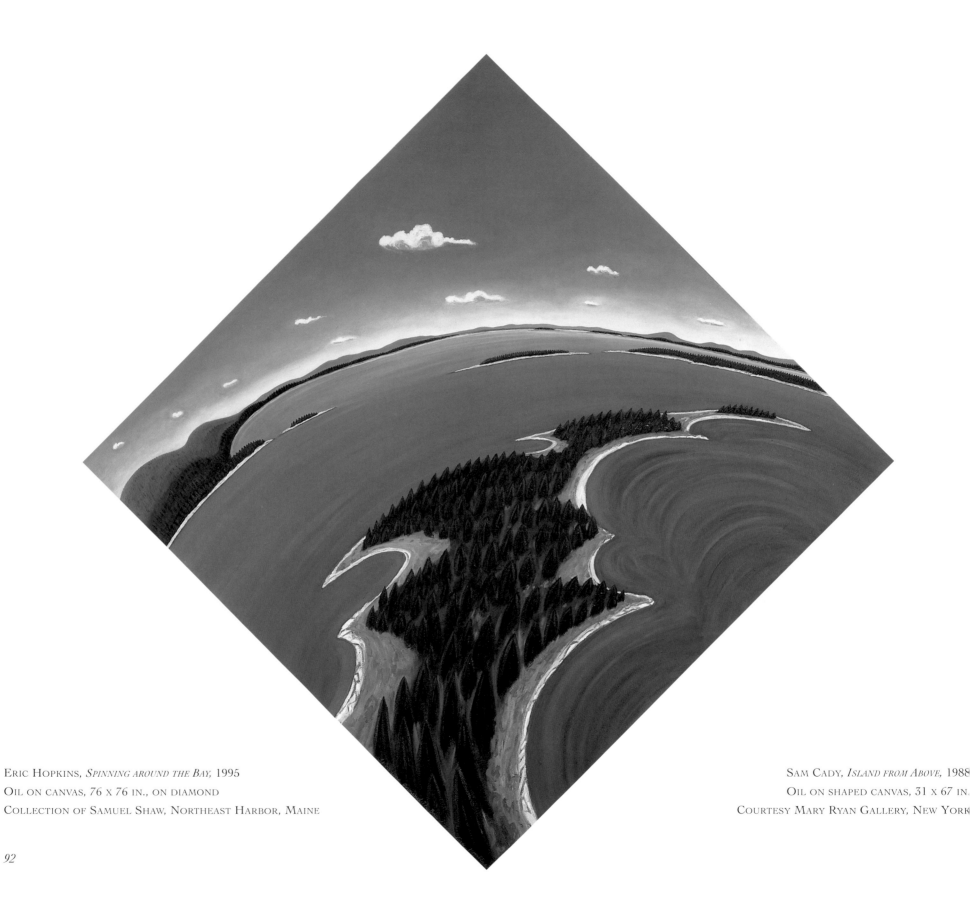

ERIC HOPKINS, *SPINNING AROUND THE BAY*, 1995
OIL ON CANVAS, 76 X 76 IN., ON DIAMOND
COLLECTION OF SAMUEL SHAW, NORTHEAST HARBOR, MAINE

SAM CADY, *ISLAND FROM ABOVE*, 1988
OIL ON SHAPED CANVAS, 31 X 67 IN.
COURTESY MARY RYAN GALLERY, NEW YORK

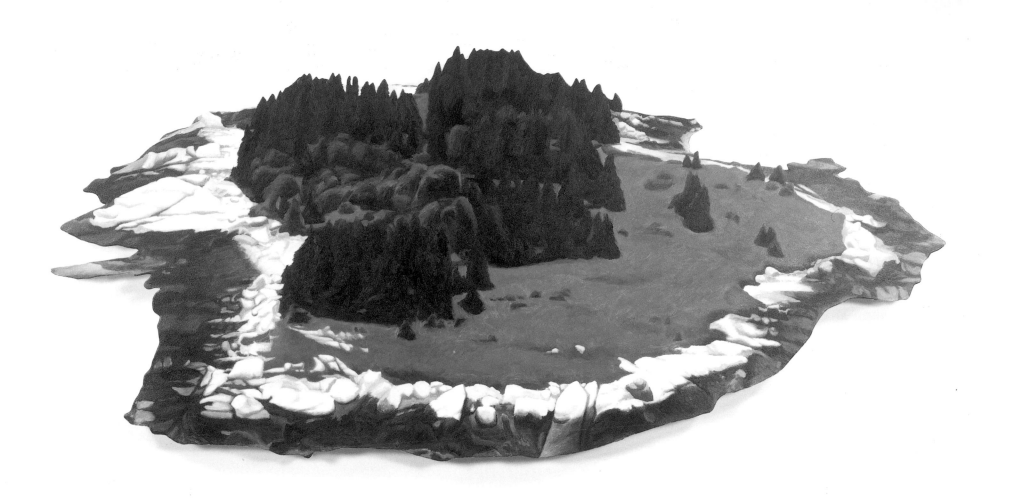

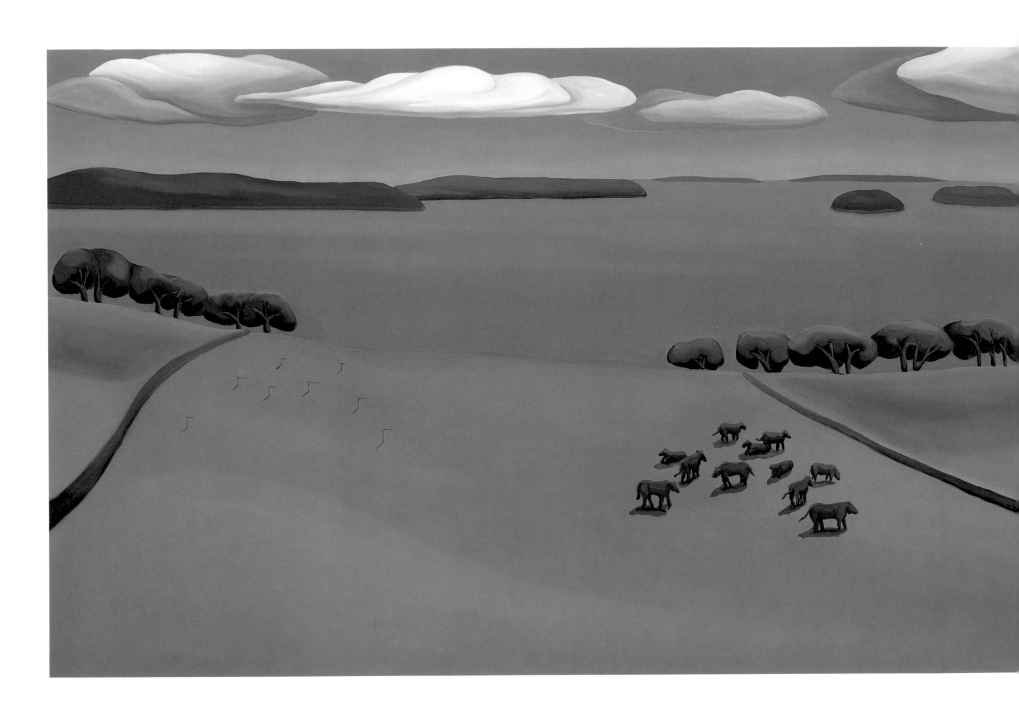

JANICE KASPER, *COWS OR CONDOS*, 1988, OIL ON CANVAS, 36 X 56 IN., COURTESY CALDBECK GALLERY, ROCKLAND, MAINE, PHOTOGRAPHY BY WILLIAM THUSS

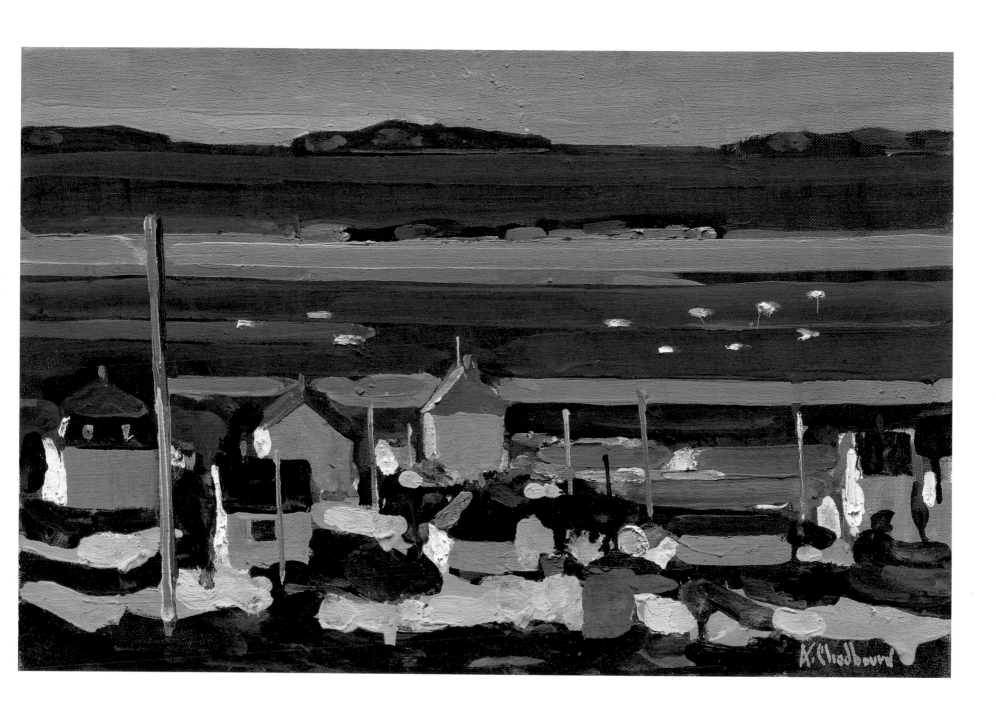

ALFRED CHADBOURN, *VIEW OF STONINGTON*, C. 1987, OIL ON CANVAS, 30 X 36 IN., PRIVATE COLLECTION, COURTESY FROST GULLY GALLERY

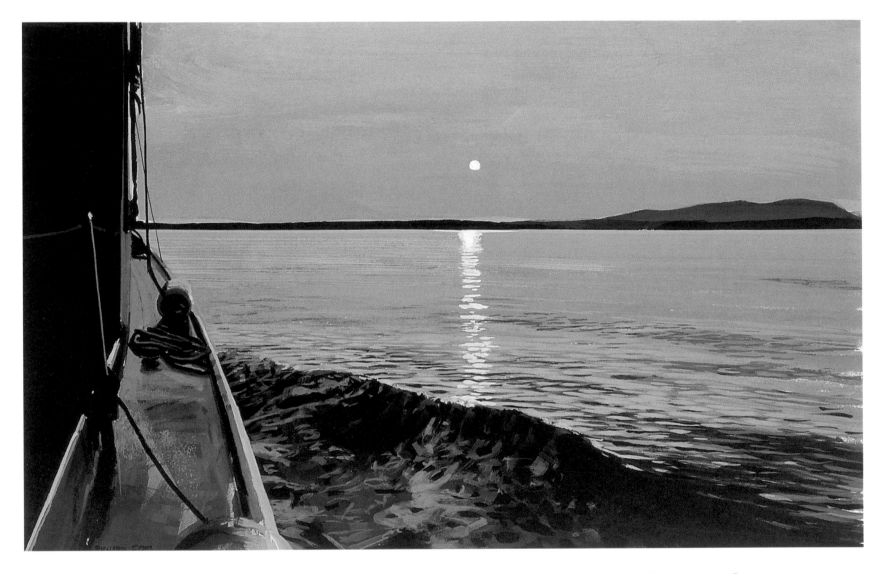

RICHARD ESTES, *MOUNT DESERT III*, 1996, OIL ON PAPER, 10 X 16 IN., © RICHARD ESTES, 1997, COURTESY MARLBOROUGH GALLERY

The stirring air
Freshens behind us now; the island gleams
A moment more; but now such distance seems
An optical illusion like the past
We carry with us always....

For we are here
Where we had started from, and far and near
Become the very thing that time will be:
A miscellany, like the summer sea.

—Samuel French Morse, from "A Trip Outside"